GAME FACES

PETER DEVEREAUX

GAME FACES

EARLY BASEBALL CARDS FROM THE LIBRARY OF CONGRESS

Preface by Carla D. Hayden

Foreword by John Thorn

Smithsonian Books | Library of Congress

Washington, DC

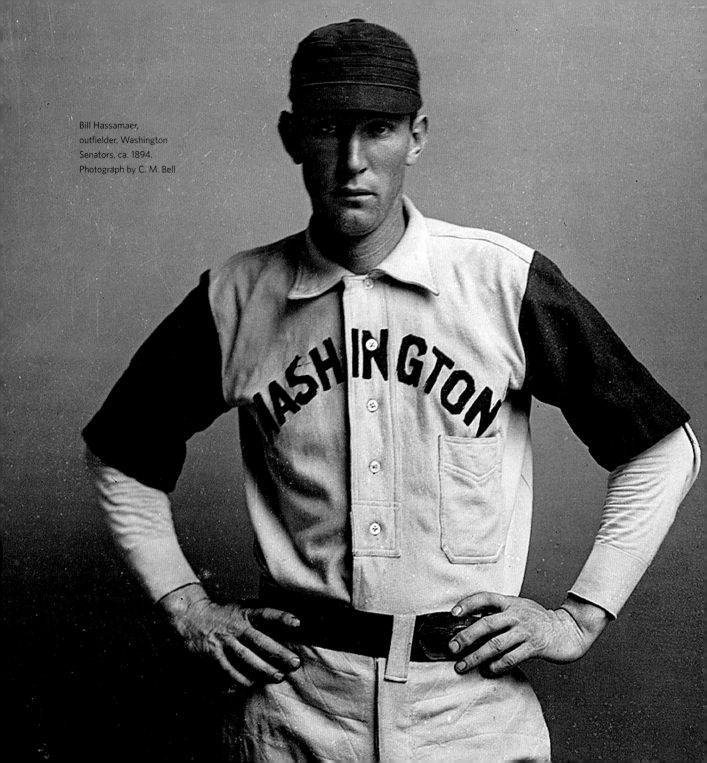

Bill Hassamaer,
outfielder, Washington
Senators, ca. 1894.
Photograph by C. M. Bell

CONTENTS

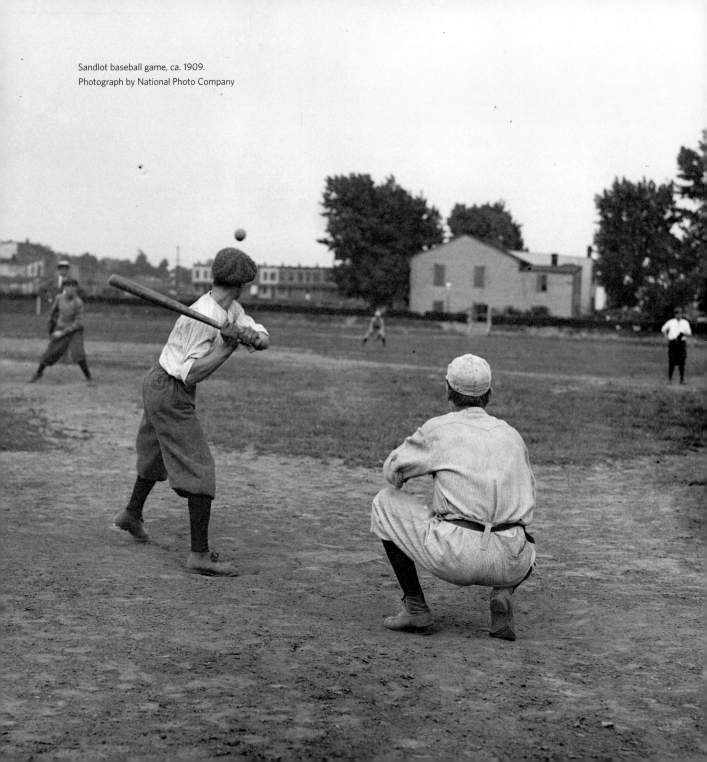

Sandlot baseball game, ca. 1909.
Photograph by National Photo Company

Since the nation's earliest days, Americans have collected objects both precious and ordinary, reflecting their interests and preserving for posterity aspects of the time and place in which they lived. In attics, basements, living rooms, barns, and garages, Americans have carefully accumulated, and often faithfully cataloged, playbills, tickets, broadsides, and postcards, as well as fine art and rare books. Often called the "Nation's Memory," the Library of Congress has acquired many such collections over the past two centuries. Together they compose a sprawling record of printed ephemera that offers a unique glimpse of our shared past from the seventeenth century to the present. These memorabilia reveal advances in photography and printing technology and also offer insights into the nation's developing popular culture as inexpensive printed materials began to circulate widely.

First created as advertising aids, baseball cards celebrate America's national pastime as well as its entrepreneurial spirit. The colorful cards appealed immediately to baseball fans of all ages, and their widespread availability spurred their popularity. Their charm persists today, as the images they bear of players who inspired the first "bugs and cranks" (a term for baseball supporters) bring the history of the game to life.

As the oldest federal cultural institution in the United States, the Library of Congress serves as a repository for unique treasures as well as mementoes of daily life, protecting and preserving these artifacts for future generations. With more than 167 million items in the collection, including more than 2,100 baseball cards, there is something for everyone to explore. I invite you to visit the Library, either in person or online at www.loc.gov, and see what sparks your imagination.

Carla D. Hayden
Librarian of Congress

Carla Hayden

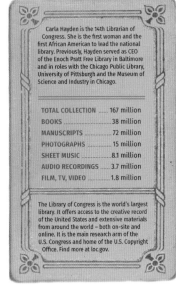

Carla Hayden is the 14th Librarian of Congress. She is the first woman and the first African American to lead the national library. Previously, Hayden served as CEO of the Enoch Pratt Free Library in Baltimore and in roles with the Chicago Public Library, University of Pittsburgh and the Museum of Science and Industry in Chicago.

TOTAL COLLECTION	167 million
BOOKS	38 million
MANUSCRIPTS	72 million
PHOTOGRAPHS	15 million
SHEET MUSIC	8.1 million
AUDIO RECORDINGS	3.7 million
FILM, TV, VIDEO	1.8 million

The Library of Congress is the world's largest library. It offers access to the creative record of the United States and extensive materials from around the world – both on-site and online. It is the main research arm of the U.S. Congress and home of the U.S. Copyright Office. Find more at loc.gov.

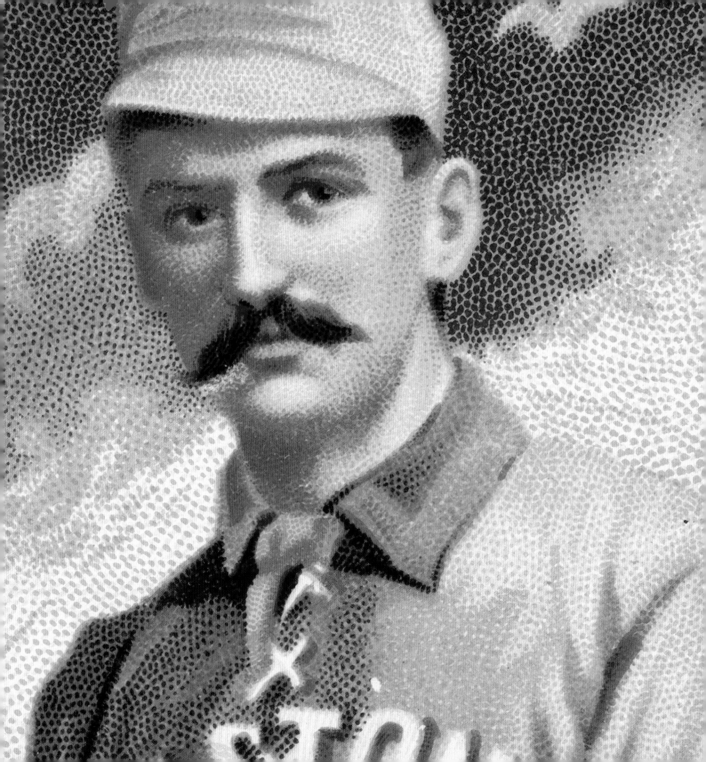

John Thorn
Official Historian of Major League Baseball

I f Marcel Proust had been a boy in the 1950s, as I was, he might have written of baseball cards, rather than of madeleines and lime-blossom tea, in his *Swann's Way*:

No sooner had the colored cardboard touched my palm than a shudder ran through me and I stopped, intent upon the extraordinary thing that was happening to me. An exquisite pleasure had invaded my senses, something isolated, detached, with no suggestion of its origin. . . . Whence did it come? What did it mean? How could I seize and apprehend it? . . .

And suddenly the memory revealed itself: the smell of the brittle bubble gum and the sight of the icon fused, recalling for me the joy and adventure of communing with my baseball hero, transferring his awesome power to my hopeful yet puny self, and then—with an artful wrist snap against a stoop—sending him into combat with other worthies, possibly to see him vanquished, perhaps never to return to my hand.

The sight of the baseball card had recalled nothing to my mind before I held it. Then, all from the feel of the board and the imagined, if not ineradicable, whiff of gum, I recalled a steaming city sidewalk on a summer afternoon, and adventure, and joy. All from a baseball card.

Time stands still in baseball, that most meticulously recorded of all human activities. Past and present overlap in a common space, as in a Venn diagram: each intact and discrete, but through imagery and, increasingly, statistics, each ancient worthy depicted on a card may, at a moment's notice, confront a modern upstart. Gloriously, baseball's ghosts spring to life everywhere, from the daily press to dinner-table conversations. As a home run total soars for an Aaron Judge or a Giancarlo Stanton, the ghosts of Roger Maris, Hank Greenberg, and Babe Ruth rise to play invisibly alongside him.

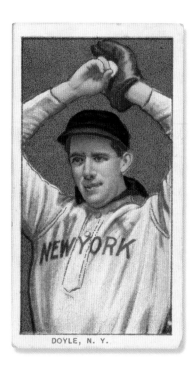

Judd Bruce "Slow Joe" Doyle, pitcher, New York Highlanders, 1909–11, American Tobacco Company White Borders (T206)

Opposite: Michael "King" Kelly, outfielder, Boston Beaneaters, 1888, Goodwin Champions (N162)

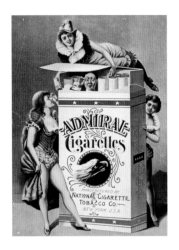

Poster, probably displayed inside tobacco shops, advertising Admiral Cigarettes, National Cigarette Tobacco Co., ca. 1895

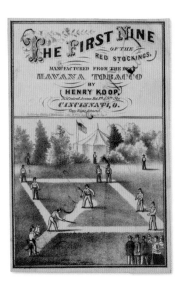

"The First Nine of the Red Stockings," tobacco package label for Havana Tobacco by Henry Koop, 1869. Lithograph by Tuchfarber, Walkley, and Moellmann

Had Proust been an American boy at the turn of the twentieth century, he would have recalled not the cloying smell of bubble gum but the pungent aroma of tobacco. Manufacturers of cigars, cigarettes, and cut plug were the first businesses to exploit baseball players, a distinctly new band of heroes, to promote their products. Boys badgered men coming out of tobacconist shops for the pictures in their cigarette packs, or they took up smoking early, incentivized by the lure of the cards. That the cards were worthless to most adults may have added to their value for children; such is the spin of generations. Once it became clear who the "customers" for the cards truly were, candy and gum manufacturers got into the act, including cards with their own products; by 1920 or so, baseball cards had ceased to be packed in with cigarettes.

It seems odd now to see athletes such as George Wright and Hoss Radbourn tacitly endorsing such products, but once upon a time, smoking, especially among men, was an unalloyed pleasure, not a personal or public menace. Cigarette companies such as Allen & Ginter's (Straight Cuts), Buchner (Gold Coin), or Goodwin (Old Judge, Gypsy Queen) inserted cards depicting baseball players into packaging as early as 1886. The largest card set ever issued—more than 2,300 separate images—was a photo series produced by the Goodwin Company for its Old Judge brand in the late 1880s.

Such venerable cards—running from 1887, when Mike Kelly was the King, to 1914, when rookie George Herman Ruth was the Babe—are the subject of the splendid book you hold in your hands. Before radio and television, fans of distant ball clubs might never see the heroes whose exploits were relayed by wire reports to local newspapers. Ballplayers might be portrayed in sports weeklies in woodcuts, steel engravings, or, by the 1890s, blurrily rendered halftone photographs, but the heroes' faces were truly revealed to the public in the color lithography of cards.

Cards were necessary to the distribution and sale of cigarettes, notably fragile items, as stiffeners. Adding images of baseball players (and other equally distant, exotic beings, from animals to admirals to actresses) to these prosaic inserts was a stroke of genius. It helped to create a nation—as would the post office, the telegraph, and later radio, television, and the Internet—from disparate regional habits and interests.

As the national economy progressed from the boom of the mid-1880s to the bust of the 1890s, so did baseball. Professional leagues came and went—the Union Association, the Players League, the American Association—and the National League was left as a twelve-team monopoly of first-rank talent, but without meaningful postseason competition for a championship, as the World Series that had launched in 1884 was no more. The exultation of those owners who emerged triumphant among their competitors was short-lived. The game was in a period of consolidation, hibernation, or stagnation; one's perspective depended upon whether one was an owner, fan, or player. Issuance of new baseball card series slowed to a trickle.

But in the heated competition following the entrance of a new challenger in the field, the American League—which in 1901 and 1902 raided National League talent and established new franchises in cities that its rivals had, over time, abandoned—interest in the grand old game revived. Baseball was once again proclaimed the national pastime, and the notion of bleacher democracy became the shared ideal for a nation of immigrants. With the National and American Leagues brokering a peace agreement in 1903, the World Series resumed as a national festival, this time played between two leagues that would endure to the present day.

Card sets proliferated, and even players deservedly obscure for their on-field accomplishments became prized for their cards. While the cards depicting Ty Cobb, Honus Wagner, or Christy Mathewson are valued in part because these men were demigods among the game's all-time greats, hunting the ephemeral and scarce presents a different challenge for the collector: his currency becomes knowledge rather than cash alone. How else to explain the current price of a Slow Joe Doyle card in the T206 series of 1909?

As Benjamin K. Edwards noted in describing his fabulous collection, which forms the focus of this book: "To the true collector the difficulty of finding old American cards is most inviting, and along with the sport thereof is the interest of research work and the insight as to the living and thinking of our people a half century ago."

Card Numbering

The card-set numbering system used in this book was devised by Jefferson R. Burdick (1900–63), a trading card and baseball card collector who donated his collection to the Metropolitan Museum of Art. He created a cataloging system for American trade cards, publishing it as the *American Card Catalog* in 1939. The ACC system, as it is now known, uses an alphanumeric code, with *N* indicating nineteenth-century cards and *T* identifying twentieth-century cards. The letter is followed by a number that designates the discrete card sets. Other collectors widely adopted—and still follow—Burdick's system.

Baseball Cards and Popular Culture Emerge

1887–1895

"How would you like to see your photograph on a cigarette package?"

"What a horrible suggestion! Only actresses, base ball players and other dreadful people have such things taken."

St. Paul Daily Globe, *August 20, 1888*

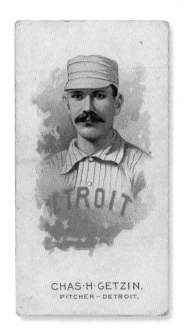

Charlie Getzien, pitcher, Detroit Wolverines, 1888, Allen & Ginter World's Champions (N29)

Opposite: "Biddefords vs. Portlands, Granite St. Grounds, Biddeford [Maine], Friday, May 22," 1885. Lithograph by Clay & Richmond

The most widely known and quintessential item in American sports memorabilia, the baseball card, emerged in the wake of the Industrial Revolution. Throughout the nineteenth century, the United States slowly changed from a principally agricultural nation to one with a mass consumer economy, a transition aided by vast improvements in commerce, industry, and publishing. The country also became increasingly infatuated with a new American sport—baseball—while growing even fonder of a long-cultivated American commodity, tobacco.

Prior to the 1830s, tobacco was another raw material, like sugar or cotton. Over time, as the use of American tobacco became more prevalent in Europe as well as in the United States, sellers began to attach tags to tobacco to distinguish the particular strains and the individual manufacturers of chewing and smoking products. By the time the Civil War broke out in 1861, branding for tobacco had become important. The war itself increased the popularity of both baseball, often played by regimental teams on both sides of the conflict, and tobacco. As Union soldiers

"On the Fly," 1867. Lithograph by Major & Knapp Engraving, Manufacturing, and Lithographic Co.

As a result of late-nineteenth-century advances in lithography, especially color lithography, new, vividly colored baseball cards could be produced, and people accustomed to simple black-and-white images often eagerly collected them.

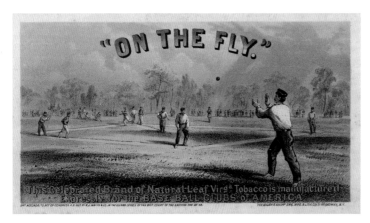

moved through the South, they snatched up sacks of tobacco and rolling papers, which they could easily stash away in their haversacks. Cigarettes imported from Europe were also plentiful and often were included in soldiers' rations, as the stateside cigarette industry was just getting started.

Following the war, soldiers returning to the North helped fuel a surge in cigarette sales. At the time, cigarettes were hand rolled, a labor-intensive and expensive process, and manufacturers strained to meet the rising demand. In 1881, James Bonsack revolutionized the industry when he patented the first automated cigarette-rolling machine, which could produce cigarettes at a rate of two hundred per minute. James Buchanan Duke, of the Durham, North Carolina, tobacco company W. Duke & Sons, learned of the new machine and invested in it, a decision that soon paid handsome dividends. His manufacturing cost plummeted and his production went through the roof as his competitors scrambled to keep up.

As the country moved deeper into this period of industrial innovation and mass production, advertising began to play a more significant role in the marketing strategies of companies looking to expand. This was especially true in fiercely competitive industries—including tobacco. The upsurge in advertising, as well as the increasing number of consumer products that required artful packaging geared to attract buyers, greatly spurred the growth of the printing industry.

Letterpress broadsides and newsprint were common throughout the nineteenth century, but as advances were made in the printing process known as lithography, publishing entered a new and extravagantly illustrated era. Color lithography, often called chromolithography, along with parallel advances in photography in the late nineteenth century (including early experiments with color photography), added to a new world flooded with enticing images.

With their newly expanded advertising budgets, American tobacco companies borrowed an idea from their European counterparts. Since the mid-1880s, manufacturers in Europe had been placing "trade cards"

in product packaging. These cards both promoted the product and gave consumers something they could collect. Because cigarette packs were soft, they contained small rectangular pieces of blank cardboard to act as stiffeners, and that cardboard was the perfect place to advertise.

The first "insert cards" in the United States were sepia-toned photographs of actresses and other celebrities mounted on cardboard. Often photographers gathered photos of women taken for purposes other than cigarette cards and sold them to tobacco companies, which included them among their products' insert cards. Chromolithography made it possible to add vibrantly colored cards to their inserts. Given the general public's limited access to books in this era, and because there were almost no color illustrations in magazines and other periodicals at the time, the cards became an instant hit. As collector Arthur Folwell wrote in a 1929 *New Yorker* article looking back at his youth, it was a time "with no newsreels, no roto sections, no picture newspapers. A good cigarette picture was no mere plaything for a boy. It was life."

These early cards usually were issued in discrete sets to foster brand loyalty. Firms began publishing insert cards with a variety of images and enticing buyers to collect full sets on their favorite subjects. Civil War generals, American Indians, birds, fish, flags, bridges, and boats were all featured on the cards, but at first images of women in provocative poses were the most popular. Soon the racy cards drew an outraged backlash from the Women's Christian Temperance Union and other monitors of public morals. By 1886, tobacco companies had settled on a new subject to feature on their insert cards: baseball players.

In the 1880s, more than half of the population lived in rural areas without major-league baseball teams. Since pictures were rare in newspapers, the only way many people could follow the burgeoning game was through box scores and printed recaps of games. The new baseball cards vividly portrayed the exciting new sport and brought ballplayer legends to life for an emergent leisure class, who spent countless hours admiring, trading, and pasting the cards in their scrapbooks. Affinity for these ephemeral cardboard relics has spanned the generations: the cards are now an established part of the country's enduring assortment of Americana.

Advertisement for Egyptian Deities cigarettes, 1900

This print ad was very typical of its time in that it shows an attractive woman holding a box of cigarettes. These types of advertisements would soon raise the ire of parents and reformers.

"Star Club" tobacco package label showing a ballgame. From R & W, "Makers of the Best Tobacco," Estramuras, Havana, 1867

Allen & Ginter World's Champions

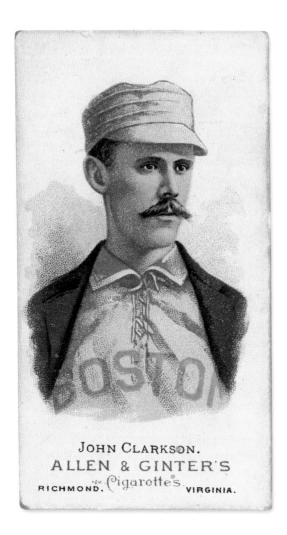

JOHN CLARKSON.
ALLEN & GINTER'S
Cigarettes
RICHMOND. VIRGINIA.

ALLEN & GINTER WORLD'S CHAMPIONS, N28, 1887
CHROMOLITHOGRAPHS, 2.75 × 1.5 INCHES

Former Confederate officer Lewis Ginter started his tobacco company after the Civil War when he partnered with business associate John Allen. Based out of Richmond, Virginia, their factory employed a few dozen women who hand-rolled each cigarette and inserted a card in each pack. Issued in 1887, this is generally acknowledged as the first significant tobacco card set. Ten baseball players are featured in the "World's Champions" series of fifty cards, which also depicts six other sports: rowing, wrestling, boxing, shooting, billiards, and pool. Along with standout ballplayers, the set included famous boxer Jack Dempsey and noted markswoman Annie Oakley. Printed by New York firm Lindner, Eddy & Claus, together the painted portraits compose one of the more striking sets ever issued and were quite popular in their day. Allen & Ginter also offered a bound album that helped collectors organize and arrange all the cards in the set, if they were lucky enough to find them all.

John Clarkson, pitcher, Boston Beaneaters

In 1887, the year this card was issued, Clarkson, one of the greatest pitchers of his era, pitched over 500 innings and started over 50 games, more than double the average for a starting pitcher of the twenty-first century. Of course, in those early days, substitutions were not allowed except for sickness or injury. If a pitcher had a rough outing, he could switch with another position player. But with his lifetime 2.81 ERA, it seems doubtful that Clarkson was called upon frequently to switch positions.

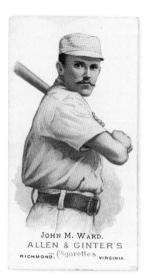

John Montgomery Ward,
shortstop, New York Giants

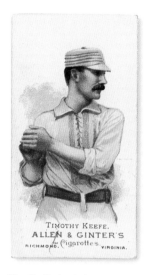

Timothy Keefe, pitcher,
New York Giants

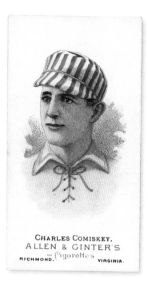

Charles Comiskey, first baseman, St. Louis Browns

The card shows Comiskey as a young man in his playing days, when he was a first baseman. Later, as an owner, he built the dominant White Sox teams of the early twentieth century, as well as his namesake South Side park, which would become forever synonymous with Chicago baseball.

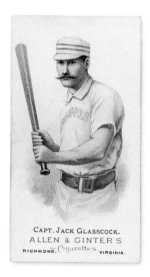

"Captain" Jack Glasscock,
shortstop, Indianapolis Hoosiers

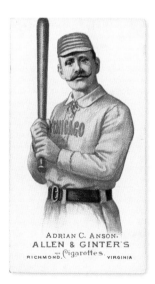

Adrian "Cap" Anson, first baseman,
Chicago White Stockings

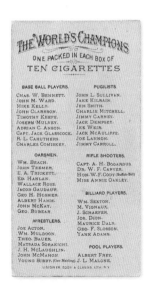

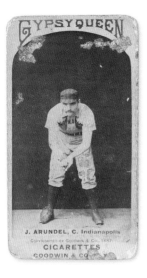

Tug Arundel, catcher,
Indianapolis Hoosiers

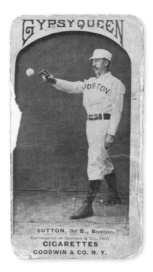

Ezra Sutton, third baseman,
Boston Beaneaters

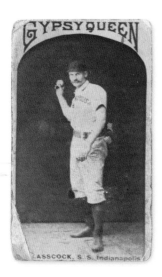

"Captain" Jack Glasscock,
shortstop, Indianapolis Hoosiers

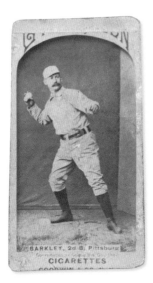

Sam Barkley, second baseman,
Pittsburgh Alleghenys

GYPSY QUEENS, N175, 1887

ALBUMEN PHOTOGRAPHS, 2.5 × 1.5 INCHES

Although probably better known for the cards that were inserted into its Old Judge brand of cigarettes, Goodwin & Company also included cards with its Gypsy Queen brand. Founded before the Civil War, New York–based Goodwin was one of the first American tobacco companies to use insert cards with baseball players' images to market its cigarettes. Though Gypsy Queen card sets featured the same type of sepia-toned photos as the cards inserted in Old Judge packs, they did not feature as many players or leagues, and because they were not cataloged by collectors, as was the Old Judge set, the exact number of cards in these sets is unknown. The cards list each player's name, position, and team. The word *Champion* appears below the photos of players on the St. Louis Browns, who won the 1886 World Series.

A middling professional player, Barkley led an interesting life once he retired from baseball. He became entangled in some nefarious dealings with Chicago crime syndicate boss Mike McDonald and later opened a notoriously raucous dive bar. It was common for ballplayers of that era to work in taverns or saloons in the offseason, and a few even owned their own bars.

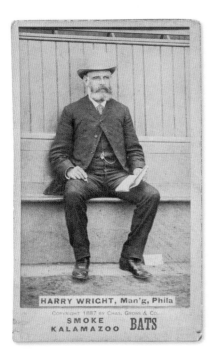

HARRY WRIGHT, Man'g, Phila
COPYRIGHT 1887 BY CHAS. GROSS & CO.
SMOKE KALAMAZOO BATS

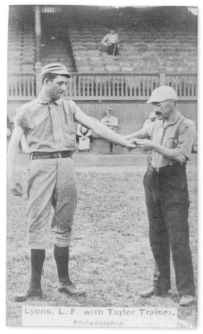

Lyons, L. F. with Taylor Trainer,
Philadelphia.

KALAMAZOO BATS, N690, 1887

ALBUMEN PHOTOGRAPHS, 4 × 2.25 INCHES

This curious set was issued by Charles Gross & Co. of Philadelphia. The sepia-toned photo cards include individual players from four teams—the New York Giants, the New York Mets, the Philadelphia Quakers (later the Phillies), and the Philadelphia Athletics—as well as group team portrait cards. The photographs for the Philadelphia cards were probably taken during a shoot showing off the new Huntingdon Street Grounds in the spring of 1887. A notice on the back of the cards, stating that "for the return of these Pictures in good order" the consumer would receive a prize, made collectors suspicious that Gross & Co. reissued the cards upon their return.

Harry Wright, manager, Philadelphia Quakers

———

Wright's baseball lineage goes all the way back to the game's first paid professional club, the 1869 Cincinnati Red Stockings, the so-called First Nine. After his playing career ended, Wright managed ball teams for 15 seasons. His final season as manager was spent with the Philadelphia Quakers.

Harry Lyons, outfielder, and Billy Taylor, trainer, Philadelphia Quakers

———

While the card shows the trainer, Taylor, examining the arm of a player identified as Harry Lyons, many collectors contend that the player is in fact pitcher and first baseman Jim Devlin. Neither player played more than a handful of games for Philadelphia's team in 1887, which may have led to the confusion.

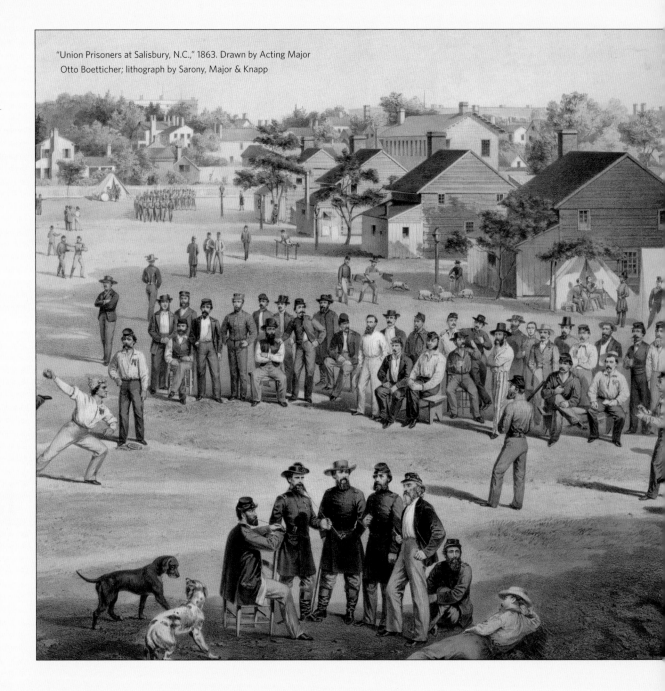

"Union Prisoners at Salisbury, N.C.," 1863. Drawn by Acting Major
Otto Boetticher; lithograph by Sarony, Major & Knapp

THE ORIGINS OF BASEBALL

Come, jolly comrade, here's the game that's played in open air
Where clerks and all the indoor men can profit by the share
'Twil make the weak man strong again
'Twil brighten every eye
And all who need such exercise should catch it on the fly.

"Catch It on the Fly Base Ball Song & Chorus," Bisco and L. B. Starkweather, 1867

Baseball has no single inventor or tidy origin. It evolved out of a variety of informal games that children played in the eighteenth and early nineteenth centuries, with quirky names such as "trap ball," "two-old-cat," and "town ball." Physical play with a ball and a stick, with little motivation beyond pure enjoyment, has an almost primal dimension, as Harold Seymour explains in his classic tome *Baseball: The Early Years* (1960): "Projecting one's power by swatting and throwing an object hard and far, and experiencing the excitement of the race to reach base ahead of the ball, satisfied elementary human urges."

As those urges grew up, they began to take on a more structured, defined form. Although popular lore claims baseball was born in a bucolic setting in Cooperstown, New York, sired by Abner Doubleday, it actually can be traced to cities, particularly New York City, where organized baseball games could be found as early as the 1820s. Parks and public squares were scattered across Manhattan to provide some respite from the foul air and grime created by overcrowded conditions. As more people settled into monotonous, deskbound jobs, they began to enjoy physical exercise in these parks. Young clerks, yearning for a release, embraced the game as they confronted a new urban malaise.

Like other aspects of U.S. history that are wrapped in folktales, popular misconceptions and outright fabrications often obscure the foggy, tangled origins of baseball. Baseball's relationship to the Civil War is fraught with myths, contends baseball historian John Husman. His scholarship has debunked one story that claimed northern soldiers taught baseball to southern soldiers. Husman's research shows that many times it was the other way around, with Confederate prisoners teaching the game to Federal guards.

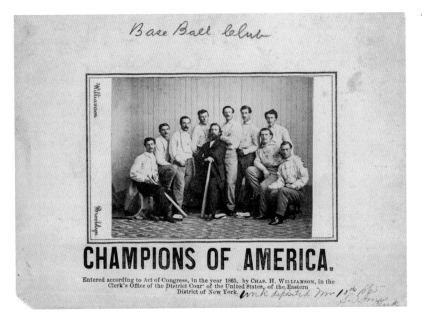

Base Ball Club

CHAMPIONS OF AMERICA.

Entered according to Act of Congress, in the year 1865, by CHAS. H. WILLIAMSON, in the Clerk's Office of the District Cour' of the United States, of the Eastern District of New York.

"Champions of America," Brooklyn, 1865. Photograph by Charles H. Williamson

Mounted on a card, this photo of the Brooklyn Atlantics was passed out as a souvenir to fans, a precursor to the smaller tobacco cards.

Amateur ball clubs or fraternities made up of volunteer firemen, accountants, and office clerks, as well as manual laborers such as shipbuilders and mechanics, popped up in a vast number of northeastern cities in the 1850s. Many historians credit New York's Gotham Ball Club and the Knickerbockers, among others, with shaping the game's early rules and scorekeeping. When members of New York–area teams held a convention in 1857 to revise existing rules, they debated the "Laws of Base Ball," drafted by Daniel Lucius "Doc" Adams, whose proposals were widely adopted. The game as it was played then probably would confuse modern fans, yet such familiar features as the prescribed ninety feet between bases, nine players to a side, and nine innings of play would be instantly recognizable.

Baseball continued to evolve and attract new players and fans, even during the Civil War. When the conflict ended, the recreational spirit of the fraternities began to erode as the game grew in popularity and professionalism. Rising urban communities swelled with a native-born populace as well as with displaced immigrants who developed their new American identities partly through their strong feelings for their local clubs. Winning was paramount, and by the late 1860s, "ringers,"

especially ones from the working class, were not just playing for the fresh air and exercise, as ballplayers were generally expected to do at this time, but routinely were being paid under the table. The emerging sporting press began to take notice of the fervent spectators and fiercely competitive, skillfully played games in urban centers.

Businessmen soon started backing teams, and promoters collected gate receipts at enclosed parks, where gamblers swarmed around the raucous, surging crowds. A few holdouts resisted what they lamented as the tarnishing of their honorable, "gentlemanly game." But their protests were in vain, as a new generation adopted the changing game—a game that did not always reflect the ideals of its Victorian patronage. Both baseball and the American nation, with its rapidly expanding economy, were moving in a new direction.

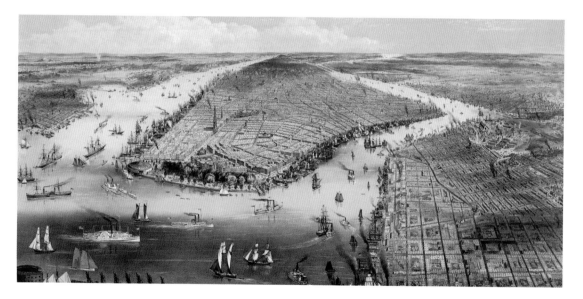

"View of New York: Jersey City, Hoboken & Brooklyn," 1858. Drawn by Charles Parsons; lithograph by Currier & Ives

While Philadelphia, Boston, and many other New England towns all played a role in the development of baseball, Manhattan, Brooklyn, and Hoboken were where the game really took off. Historians cite Hoboken's Elysian Fields as the location of the first "match game" between two organized baseball clubs.

Jim Donahue, catcher,
New York Metropolitans

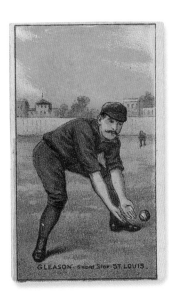

Bill Gleason, shortstop,
St. Louis Browns

BUCHNER GOLD COIN, N284, 1887

CHROMOLITHOGRAPHS, 3 × 1.75 INCHES

●

This set, issued by D. Buchner & Company of New York with its Gold Coin brand of tobacco, featured other subjects besides baseball players, including jockeys, actors, police inspectors, and fire chiefs. Using color lithographs set over inked background sketches, these cards are especially interesting because generic images of ballplayers in action positions were used recurrently for more than one player. The same pose was used for each position: the second baseman was always shown with a ball and placing a tag, while the center fielder was shown looking up at a fly ball. A mustache might be added or the uniform color changed to try to faithfully resemble an actual player, but the background sketches were identical. These gimmicks did not pass muster with a young Arthur Folwell, who later wrote about them for the *New Yorker* in 1929: "There were limitations and absurdities about the Gold Coin ball players, however, which even a small boy could detect and resent."

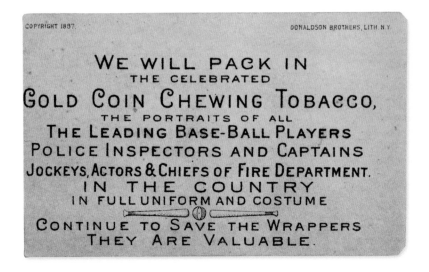

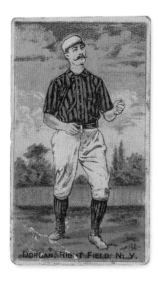

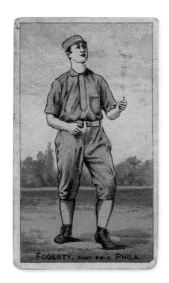

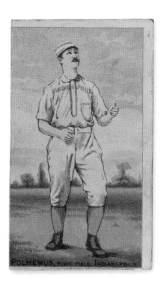

Mike Dorgan, outfielder,
New York Giants

James G. Fogarty, outfielder,
Philadelphia Quakers

Mark Polhemus, outfielder,
Indianapolis Hoosiers

The fact that the same picture was employed for different players creates some interesting juxtapositions. For example, while Jack Farrell and Buck Ewing were both professional ballplayers, the former was a respectable catcher and second baseman in the big leagues for eleven seasons, while the latter was one of the most popular players of the nineteenth century and one of the first inductees into the National Baseball Hall of Fame.

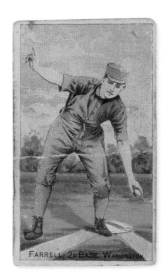

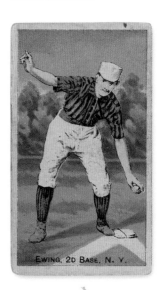

Jack Farrell, second baseman,
Washington Statesmen

William "Buck" Ewing, second
baseman, New York Giants

Clarence "Kid" Baldwin, pitcher,
Cincinnati Red Stockings

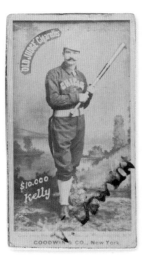

Michael "King" Kelly, outfielder and
catcher, Chicago White Stockings

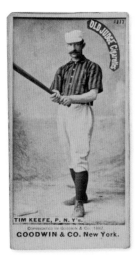

Timothy Keefe, pitcher,
New York Giants

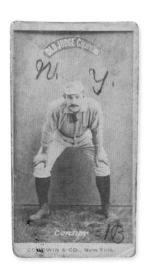

Roger Connor, first baseman,
New York Giants

OLD JUDGE, N172, 1887–1890

ALBUMEN PHOTOGRAPHS, 2.4 × 1.5 INCHES

Issued over the course of three years, Goodwin &
Company's Old Judge cards were not run-of-the-
mill cigarette cards but a sprawling, whimsical
photographic record of late-nineteenth-century
baseball. While contemporary companies offered
images of a dozen or so ballplayers in a set, the
Old Judge set included more than 518 different
players photographed in 2,345 poses and covered
almost every major- and minor-league team in
existence from 1887 to 1890. Based in New York
City, Goodwin both worked with local photog-
raphers and depended on a bevy of studios
across the country to help capture the players as
they crisscrossed the United States. Accounting
records reveal Goodwin spent more than $40,000
on "small photos" in 1887, which was quite a
sum of money in that era. Players were posed in
awkward yet charming action stances against a
stock backdrop of a cityscape or ballpark and were
shown catching or throwing balls that were being
dangled on strings. Occasionally the explosion of
flash powder, used in the photography of the time,
gave players a wide-eyed, surprised expression.

*During an era of the game better known for "small ball"
than for "long ball," Connor stood out. A powerhouse
at the plate, he held the home run record until he was
surpassed by the legendary Babe Ruth. Connor also
had the honor of hitting the major leagues' first grand
slam home run in 1881.*

PHILADELPHIA BASE BALL CLUB.

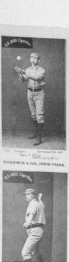
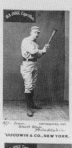
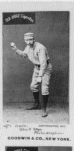
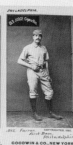
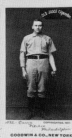
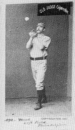

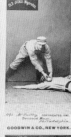
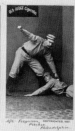

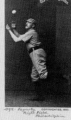

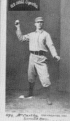

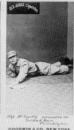
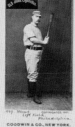
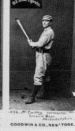
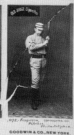

Uncut proof sheet of twenty-four full action portraits of Philadelphia Base Ball Club players, 1887

This uncut sheet of Old Judge cards provides some clues as to how the cards were produced. Team members were photographed at the same time; each player's photograph was cropped, and then all the photos were arranged in a four-by-six matrix of columns and rows. Then a prepared mat was used to frame each photo, and the arranged photos were then rephotographed and mounted to a cardboard backing. The sheet was then cut, and the individual cards were inserted in packs of cigarettes.

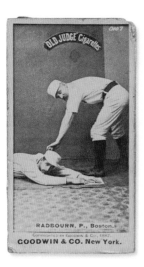

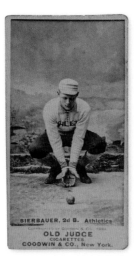

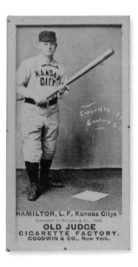

Charles "Old Hoss" Radbourn, pitcher, Boston Beaneaters

Lou Bierbauer, second baseman, Philadelphia Athletics

Billy Hamilton, outfielder, Kansas City Cowboys

In the very early days of amateur baseball, the pitcher was known as the "feeder." He would simply lob the ball at the batter so he could hit it rather than try to strike the batter out. Overhand pitching was not allowed. As the game evolved, the pitcher became much more important. In 1884, the National League rules were changed to allow a pitcher to throw from any angle, and Radbourn started an astounding 73 games and pitched more than 678 innings. His shrewd pitching style kept hitters off balance, but the strain on his arm from that record-breaking season took its toll, and Old Hoss was never the same pitcher again.

Professional baseball has a long history in Pittsburgh, and Bierbauer was the reason the city's ball team switched to their current name, the Pirates. Formerly the Alleghenys, the team played much of the 1880s in the American Association before switching to the National League. In the winter of 1891, Pittsburgh signed Bierbauer, the second baseman of the Philadelphia Athletics, who was technically not under contract. League officials were furious and called it a "piratical" act. The Pittsburgh club took it in stride and decided to adopt the name Pirates to make light of the situation.

"Sliding Billy" Hamilton was the original speed demon on the basepaths. Besides being gifted with speed, he pioneered a sliding technique that helped him evade the tag. As the Sporting News reported in 1898: "He has got base stealing down to a science, and no player succeeds in the attempt so often in proportion to times attempted. His slide is wonderful, and often he gets away from the fielder when the latter has the ball in hand waiting to touch him." A Hall of Famer, he ranks third on the all-time list of career stolen bases leaders. Coincidentally, another Billy Hamilton (born 1990), of the Cincinnati Reds, is one of the fastest runners in the major leagues in the twenty-first century.

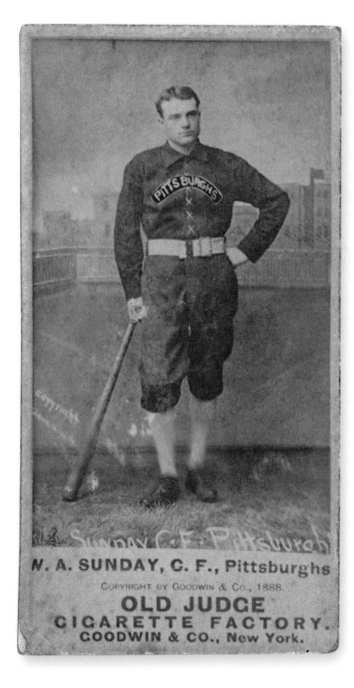

Players in the late nineteenth century frequently bounced from team to team, and it was difficult for fans to keep track of who was playing for which team. Card collector Arthur Folwell noted in a 1929 New Yorker *article that as a child he'd thought "somebody in the Old Judge shop kept a close eye on the midseason's trades" and described this Billy Sunday card. Earlier versions of the card clearly show Sunday wearing a Chicago uniform. After he was traded, rather than dragging him into the studio again, someone crudely pasted "Pittsburghs" over his chest in the image to reflect the change of teams. Similar techniques of altering cards this way were still in use as late as 1989, when baseball card manufacturer Fleer issued a Billy Ripken card; the player had an obscenity written on his bat handle, and Fleer sloppily scribbled it out.*

Allen & Ginter World's Champions

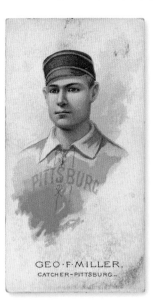

GEO·F·MILLER,
CATCHER-PITTSBURG.

George F. Miller, catcher,
Pittsburgh Alleghenys

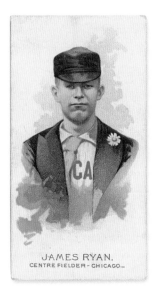

JAMES RYAN,
CENTRE FIELDER - CHICAGO.

James Ryan, center fielder,
Chicago White Stockings

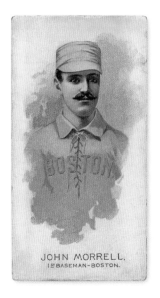

JOHN MORRELL,
1ST BASEMAN-BOSTON.

John Morrill (misspelled on card),
first baseman, Boston Beaneaters

The second set of World's Champions issued by Allen & Ginter is virtually identical to the first (page 4). It includes only six baseball players among an array of athletes including cyclists, swimmers, oarsmen, and pole vaulters. The artwork was done by Lindner, Eddy & Claus, the same firm that produced Allen & Ginter's first set. One of New York's largest lithography companies during the late nineteenth century, the firm printed thousands of cigarette cards and advertisements. All the cards in the second series are shown on this poster (opposite), also printed by Lindner, Eddy & Claus.

Opposite: Poster for Richmond Straight Cut No. 1 Virginia Brights cigarettes, Allen & Ginter, Richmond, Virginia, 1888. World's Champions second series. Lithograph by Lindner, Eddy & Claus

This promotional poster, which probably would have adorned the walls in tobacco shops of the day, showed off the true variety of sports that were featured in the sets. Major-league ballplayers were featured next to weightlifters, high jumpers, and even a few "pedestrians," competitors in a nineteenth-century form of race walking (which was funded chiefly by wagering).

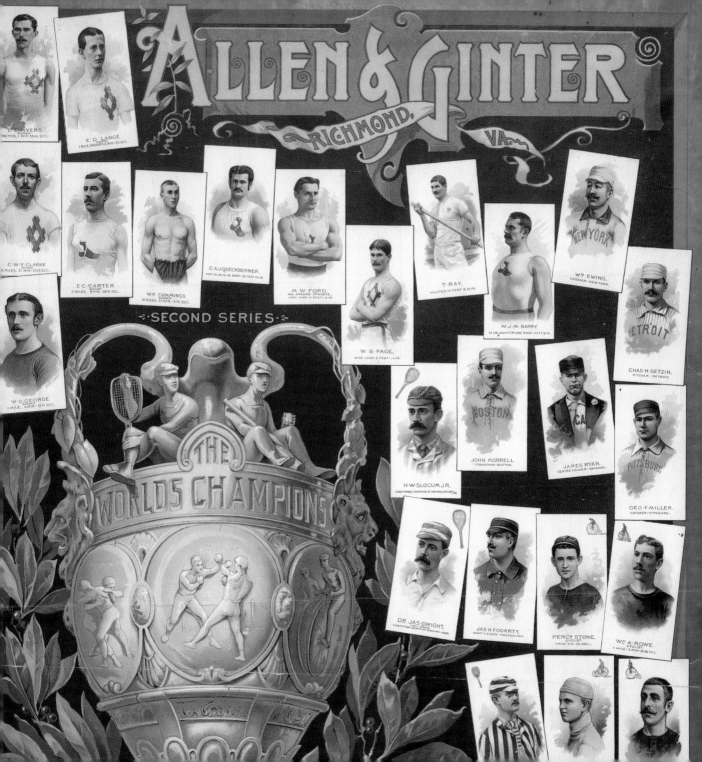

JIM CROW AT THE BALLPARK

Although there were black ballplayers throughout the nineteenth century and integrated teams were not unheard of during the game's early years, baseball, as a reflection of the country, was not exempt from racism's disgraceful influence. From the abject bigotry experienced by northern black ballplayers to the terrible violence and wretched conditions confronting black players in the South, the situation rapidly deteriorated for African American players in the late nineteenth century. It was during this tumultuous time that a few brave black ballplayers faced the prejudice of white fans, the press, and their white teammates and took the field for professional teams.

John "Bud" Fowler, who started for a Massachusetts club, the Lynn Live Oaks from the International Association league, in 1878, is recognized as the first African American to play on a professional team. A talented player, Fowler faced unremitting racism throughout his playing career. *Sporting Life* magazine declared in 1885, "The poor fellow's skin is against him. With his splendid abilities he would long ago have been on some good club had his color been white instead of black. Those who know say there is no better second baseman in the country." Eventually growing disgusted, he walked away from integrated teams and became a pivotal force in organizing all-black leagues.

Moses Fleetwood "Fleet" Walker, another black player, made his major-league debut with the Toledo Blue Stockings on May 1, 1884. At Oberlin College and the University of Michigan, Walker had been a standout athlete. A fantastic catcher, Walker excelled at the position during a time when catchers lacked modern protective gear and were frequently injured. Though he fared well behind the plate, he faced dangers from opposing players on the basepaths who sharpened the cleats on their shoes and would intentionally slide hard into Walker, spiking his legs. Walker persevered and left college to sign with the Toledo club.

In 1883, a year before the Blue Stockings made the jump to the American Association, one of the most famous teams in baseball, the Chicago White Stockings (today's Cubs), passed through Toledo and played an exhibition game. Chicago's best player, future Hall of Famer and notorious racist Adrian "Cap" Anson, refused to take the field against the Blue Stockings because Walker was slated to play. Anson eventually yielded to avoid losing his cut of the ticket sales, but the August 11, 1883, edition of the *Toledo Daily Blade* quoted Anson as saying, "We'll play this here game, but won't play never no more with the nigger in."

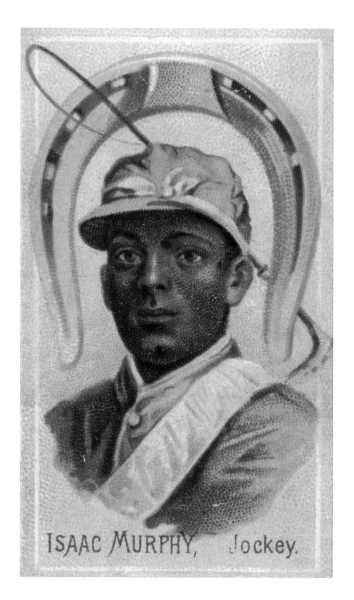

Isaac Murphy, jockey, 1888, Goodwin Champions (N162)

Murphy, one of the first African Americans to appear on a sports card, was among the top jockeys in U.S. horse racing history. Appearing in the gorgeous N162 Goodwin Champions set, Murphy raced in eleven Kentucky Derbys during his career, winning the race in 1884, 1890, and 1891. He was the first three-time winner of the Derby and the first to win successive "Runs for the Roses." He boasted a staggering 44 percent win record across all races and also won the American Derby, which was actually the more prestigious race of the era. Horse racing was very popular in the late nineteenth century, and jockeys frequently were featured on cigarette cards, although ironically, this Murphy card was issued in 1888, the year after the color line was instituted in baseball.

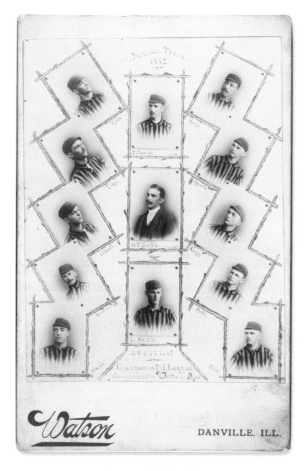

Danville Browns, 1889. Photograph by S. A. Watson

The minor-league Danville Browns were part of the Illinois-Indiana League. The 1889 team featured an African American player, Richard A. Kelly, on its roster.

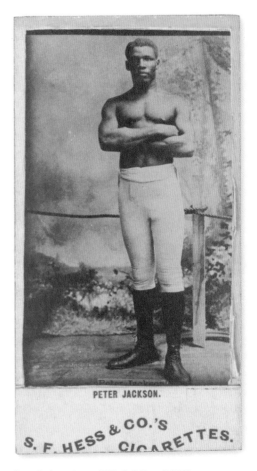

Peter Jackson, boxer, 1888, S. F. Hess (N332)

Jackson, a champion heavyweight boxer from the Danish West Indies, was one of the greatest fighters of the nineteenth century, yet he was denied a title bout with white champion John L. Sullivan.

During an era when many whites despised the idea of African Americans voting or riding in the same conveyances they did, the idea of a black man playing baseball with white players was intolerable. Anson's protest marked both the beginning of the end of Walker's career and the onset of widespread discrimination against all black ballplayers. The following year, Toledo's manager received a letter prior to a game the team was scheduled to play in Richmond, Virginia, which threatened to lynch Walker if he played. After facing injuries, threats of violence, and the burden of playing in front of such hostile crowds, Walker was released from the team later that season. Walker continued to play baseball for minor-league teams. He so impressed another future Hall of Famer, John Montgomery Ward, that Ward tried to convince the New York Giants to sign him. The team refused. Professional baseball remained segregated until Jackie Robinson broke the color line in the 1940s.

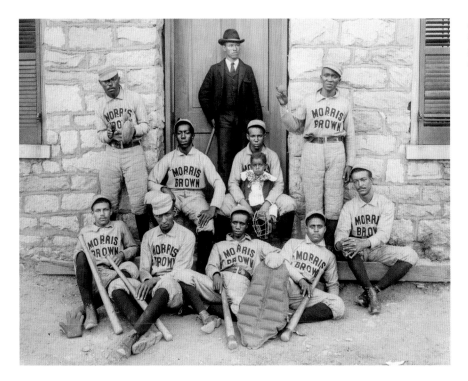

African American baseball players from Morris Brown College, 1899 or 1900

Allen & Ginter World's Champions

Allen & Ginter stuck with its World's Champions theme and issued another set in 1888 that featured six baseball players. Each card in this set was unusually large and elaborate, with decorative imagery brushed in around the inset of the card used for the Allen & Ginter N29 set (page 18). Lindner, Eddy & Claus produced three different colorful background designs incorporating generic baseball scenes and equipment. The level of detail in the full-color prints on the thick white card stock makes this set of cards one of the most impressive produced in the nineteenth century.

Above right: Hailed as the greatest catcher of the nineteenth century, Ewing is credited with being one of the first catchers to crouch close to the batter and use a large, padded mitt. Previously, it was customary for the catcher to stand some distance behind home plate. Ewing was one of the first six individuals elected to the Hall of Fame by the Hall's Veterans Committee in 1939, cementing his legacy.

Right: Baseball players are a superstitious bunch, as Morrill (misspelled Morrell on this card) told the Washington Star in 1886: "Yes, sir, it's a fact, that professional ball-tossers are as a rule very superstitious. You see, so much chance enters into every game of ball that the boys who play game after game gradually become impressed with the belief that they can read in advance certain signs or omens which will have more or less effect upon their individual play, if not upon the result of the game."

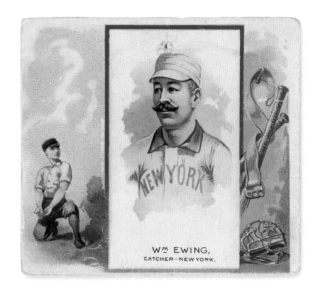

William "Buck" Ewing, catcher, New York Giants

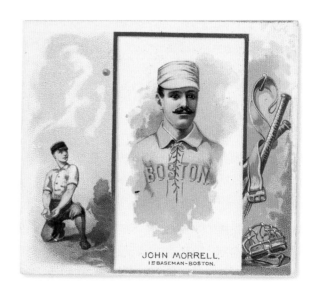

John Morrill, first baseman, Boston Beaneaters

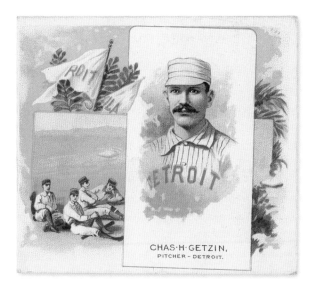

Charlie "Pretzels" Getzien, pitcher, Detroit Wolverines

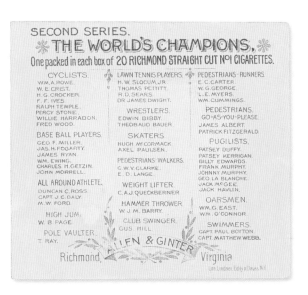

SECOND SERIES.
THE WORLD'S CHAMPIONS,
One packed in each box of 20 RICHMOND STRAIGHT CUT No I CIGARETTES.

CYCLISTS.
WM. A. ROWE.
W. E. CRIST.
H. G. CROCKER.
F. F. IVES.
RALPH TEMPLE.
PERCY STONE.
WILLIE HARRADON.
FRED WOOD.

BASE BALL PLAYERS.
GEO. F. MILLER.
JAS. H. FOGARTY.
JAMES RYAN.
WM. EWING.
CHARLES H. GETZIN.
JOHN MORRELL.

ALL AROUND ATHLETE.
DUNCAN C. ROSS.
CAPT. J. C. DALY.
M. W. FORD.

HIGH JUM
W. B. PAGE.

POLE VAULTER.
T. RAY.

LAWN TENNIS PLAYERS.
H. W. SLOCUM, JR.
THOMAS PETTITT.
R. D. SEARS.
DR. JAMES DWIGHT.

WRESTLERS.
EDWIN BIBBY.
THEOBAUD BAUER.

SKATERS.
HUGH McCORMACK.
AXEL PAULSEN.

PEDESTRIANS. WALKERS.
C. W. V. CLARKE.
E. D. LANGE.

WEIGHT LIFTER.
C. A. J. QUECKBERNER.

HAMMER THROWER.
W. J. M. BARRY.

CLUB SWINGER.
GUS. HILL.

PEDESTRIANS-RUNNERS.
E. C. CARTER.
W. G. GEORGE.
L. E. MYERS.
WM. CUMMINGS.

PEDESTRIANS.
GO-AS-YOU-PLEASE.
JAMES ALBERT.
PATRICK FITZGERALD.

PUGILISTS.
PATSEY DUFFY.
PATSEY KERRIGAN.
BILLY EDWARDS.
FRANK MURPHY.
JOHNNY MURPHY.
GEO. LA BLANCHE.
JACK McGEE.
JACK HAVLIN.

OARSMEN.
WM. G. EAST.
WM. O'CONNOR.

SWIMMERS.
CAPT. PAUL BOYTON.
CAPT. MATTHEW WEBB.

ALLEN & GINTER
Richmond Virginia

The reverse of Getzien's card lists the other "World's Champion" athletes featured in the set.

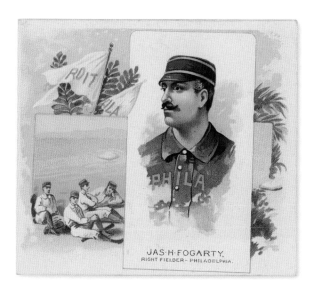

James G. Fogarty, right fielder, Philadelphia Quakers

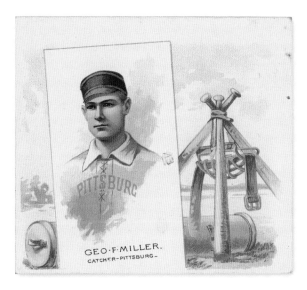

George F. Miller, catcher, Pittsburgh Alleghenys

New York–based Goodwin & Company issued this magnificent set of fifty lithographic cards printed by George S. Harris & Sons, one of the top fine-art printers of the late nineteenth century. In addition to eight baseball players (among them four future Hall of Famers), the set includes boxer Jack Dempsey and the Yale football card of Harry Beecher, which is widely recognized as the first football card.

Wrestlers, a marksman, swordsmen, and chess players are also featured, as is the famous hunter and showman "Buffalo Bill" Cody. Set N162 is especially known for its vibrant backgrounds, depicting colorful skies and incredibly detailed artwork. As a whole, Goodwin Champions stands as one of the more impressive examples of nineteenth-century chromolithography.

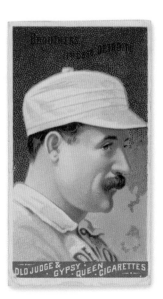

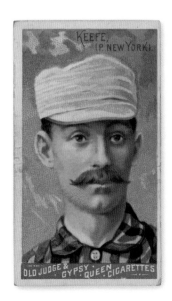

Dan Brouthers, first baseman, Detroit Wolverines

Timothy Keefe, pitcher, New York Giants

The reverse side of the Keefe card lists the dozens of other athletes featured in this set.

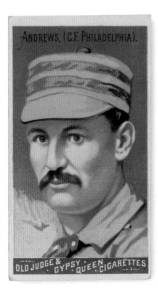

Ed Andrews, second baseman,
Philadelphia Quakers

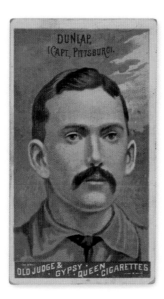

Fred Dunlap, second baseman,
Pittsburgh Alleghenys

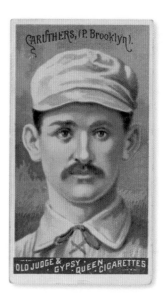

Bob Caruthers, pitcher, Brooklyn
Trolley-Dodgers

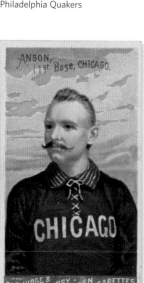

Adrian "Cap" Anson, first baseman,
Chicago White Stockings

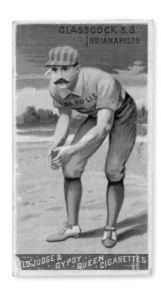

"Captain" Jack Glasscock, shortstop,
Indianapolis Hoosiers

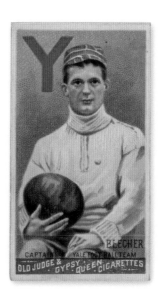

Harry Beecher, captain, Yale Football

28

S. F. Hess California League

It remains unclear why S. F. Hess & Company, based in Rochester, New York, produced this set featuring regional ballplayers from the small, independent California League, based more than three thousand miles away. The forty known cards in this series show full-color drawings of players in various poses, and several players have both a batting card and a fielding card. The set even includes an umpire: John F. Sheridan, who got his start in the independent leagues before

becoming one of the most respected umpires in the game. Sheridan, who called four of the first seven World Series, was also one of the first umps to crouch closely behind the catcher to gain a better vantage point. The original California League lasted from 1887 to 1889 in its first incarnation. The set represents all four clubs that fielded teams in 1888: the Oakland Greenhood & Morans, the San Francisco Haverlys, the San Francisco Pioneers, and the Stocktons, from Stockton, California.

Hardie was not a household name in the 1880s, but his career is a great example of the trajectory of many players who bounced around between the major and minor leagues. Initially called up to the big leagues by Harry Wright to catch for his Philadelphia squad, Hardie did not last long after struggling behind the plate. After another stint with Chicago, he landed back in the California League before getting one last shot with Baltimore in 1891. Eventually heading back west once again, Hardie finished his career in the minors before becoming an umpire.

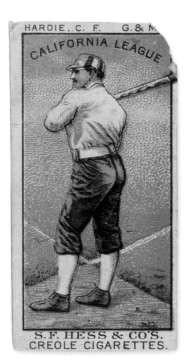

Lou Hardie, center fielder,
Oakland Greenhood & Morans

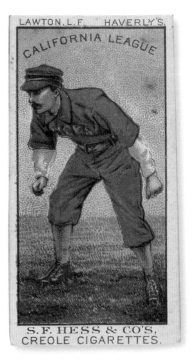

Jack Lawton, left fielder,
San Francisco Haverlys

The S. F. Hess tobacco company of Rochester, New York, created one of the most peculiar and obscure sets ever produced. For reasons unknown, the set of forty-six cards featured newspaper boys who each represented his town's paper in a baseball league. The sepia-toned cards, issued for eight cities, each have the boy's name, position, and city printed on the front. Hawking newspapers on the corner was common employment for young boys in the nineteenth century. Earning less than fifty cents a day, the scrappy "newsies," as they were called, worked long hours and late into the night trying to sell their papers. Many were homeless, malnourished, and smoked cigarettes, whose packages included the cards on which they were ironically featured.

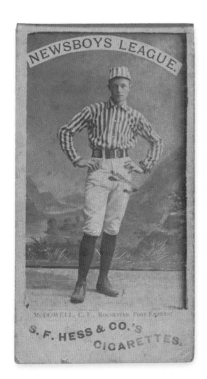

C. F. McDowell, *Rochester Post Express*

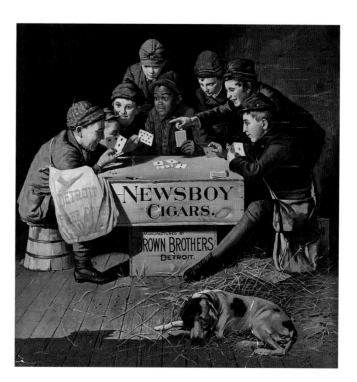

Print advertisement for Newsboy Cigars, manufactured by Brown Brothers, Detroit, 1894

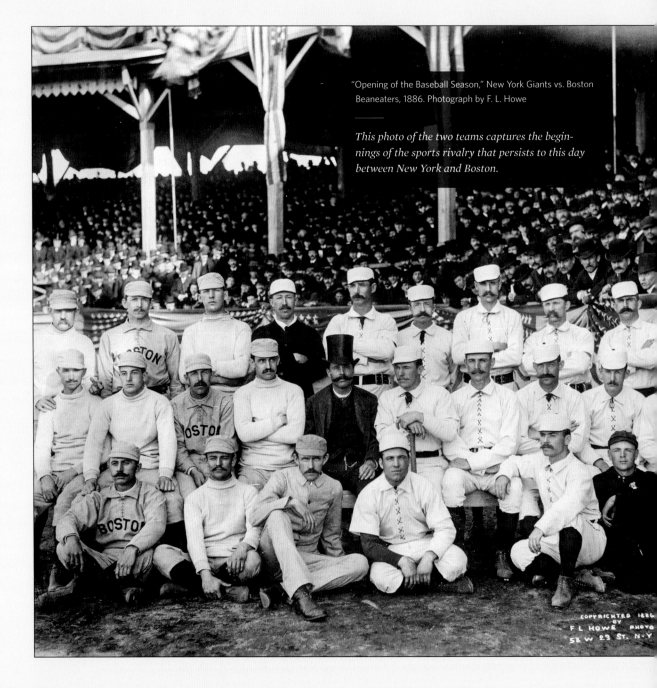

"Opening of the Baseball Season," New York Giants vs. Boston Beaneaters, 1886. Photograph by F. L. Howe

This photo of the two teams captures the beginnings of the sports rivalry that persists to this day between New York and Boston.

THE FORMATION OF THE NATIONAL LEAGUE

Baseball transitioned from a leisurely, informal athletic pursuit to a tightly controlled commercial enterprise during the decade after the Civil War. The principal catalyst for this transition was the "enclosure movement," which saw fences built around parks, making it easier to charge spectators an entrance fee. The 1869 Cincinnati Red Stockings ushered in the era of pro teams. Organized and managed by former professional cricket player Harry Wright, the Red Stockings were the first team to openly pay all their players. They rolled across the country, dominating other teams, and went undefeated for the season. Success on the field did not, however, translate into financial success: Wright's club reaped a less than enviable net profit of $1.25 for the season.

Other towns and impresarios took note of what Cincinnati's club was doing, boosting the manifest-destiny spread of professional baseball across the

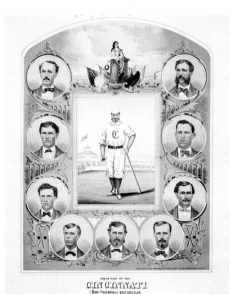

"First Nine of the Cincinnati (Red Stockings) Base Ball Club," 1869. Lithograph by Tuchfarber, Walkley & Moellman

Midwest and as far west as California. Over the next decade, most metropolitan areas developed professional clubs, although many were transitory.

In 1871, the first professional baseball league, the National Association of Professional Base Ball Players, was established. However, the stability of this loose confederation of ball clubs was tenuous at best. By 1875, the league was in shambles. Rampant gambling, fixed games, and intoxicated players, who also frequently switched teams, threatened baseball's first organized league.

A keen observer of the missteps of the National Association, Chicago White Stockings owner William A. Hulbert seized the opportunity to form a new league that would last and turn a profit. After pilfering players from other clubs, Hulbert stacked his own Chicago club with talent and, in the winter of 1876, staged a coup, inviting the best clubs from the National Association to join

the new National League of Professional Baseball Clubs, or National League (NL). Hulbert, determined to succeed, included only teams from larger cities and instituted strict guidelines that established the owner's firm authority over the players.

While a marked improvement from the chaos of the National Association, the NL still contended with gamblers, shifting players, and other issues, limping along in those early years perpetually on the verge of collapse and its troubles exacerbated by the economic depression following the Panic of 1873. Most of its member teams struggled to survive—many were unable to pay their players, and some were forced to fold. In the first decade of the NL, only Chicago and Boston were consistently able to field teams. Yet Hulbert's steadying presence, along with the league's control of baseball's biggest markets, including those two cities, shepherded the NL through its shaky start. As it continued operations, the NL established regular, paid umpires for games and fixed league schedules. As historian Harold Seymour notes, "In the years to come, the League would bring to professional baseball both stability and the disruption of bitter trade wars. . . . It would build up public confidence in baseball, yet at times create public disillusionment." This disillusionment haunted baseball throughout the late nineteenth century as Hulbert sought to sanitize the sport of its rough-hewn image of excessive drinking and fixed games.

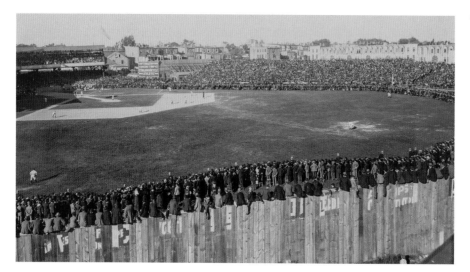

"The Winning Team," Boston Beaneaters vs. Baltimore Orioles, played at Baltimore, 1897

In 1897, the year this game was played, Boston finished ahead of Baltimore in the National League standings.

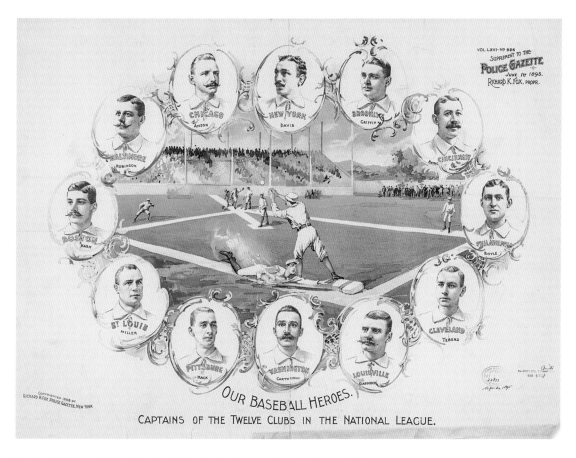

"Our Baseball Heroes," 1895. Originally published in *Supplement to the Police Gazette,* vol. 66

This print shows bust portraits of the captains of the twelve baseball teams in the National League. Clockwise from top: George Davis of New York, Michael J. Griffin of Brooklyn, William "Buck" Ewing of Cincinnati, John A. Boyle of Philadelphia, Oliver W. "Patsy" Tebeau of Cleveland, "Captain" Jack Glasscock of Louisville, Edward C. Cartwright of Washington, Connie Mack of Pittsburgh, George F. Miller of St. Louis, Billy Nash of Boston, Wilbert Robinson of Baltimore, and Adrian "Cap" Anson of Chicago.

W. S. Kimball Champions

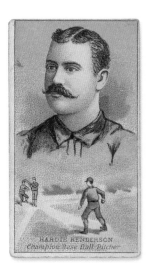

James "Hardie" Henderson, pitcher,
Brooklyn Trolley-Dodgers

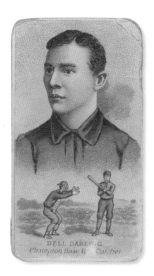

Conrad "Dell" Darling, catcher,
Chicago White Stockings

Earnest A. Burch, outfielder,
Brooklyn Trolley-Dodgers

James Edward "Tip" O'Neill,
outfielder, St. Louis Browns

W. S. KIMBALL CHAMPIONS, N184, 1888
CHROMOLITHOGRAPHS, 2.75 × 1.5 INCHES

W. S. Kimball, of Rochester, New York, produced this set in direct response to the World's Champions sets issued by Allen and Ginter (pages 4, 18, and 24) and Goodwin (page 26). Like those other sets, it depicts stars of the sporting world, but it includes only four baseball players. Each of the cards features a posed color portrait of a player, set against a pastel background and positioned above a smaller drawing of the player in action. Unlike the other Champions sets, however, the N184s did not include the game's big names or future Hall of Famers, and it included other sportsmen such as pugilists, jockeys, and bicyclists. The set is also known for showcasing more unusual athletes, including a deep-sea swimmer, a heel-and-toe pedestrian, a juvenile roller skater, and a cannonball catcher.

While there were other Tip O'Neills in baseball in the nineteenth century, James Edward might have been the best. He won the American Association Triple Crown in 1887 with a .435 batting average, 14 home runs, and 123 RBIs. O'Neill (his last name is misspelled on this card) was one of the game's best hitters in the 1880s, later earning the nickname "Canada's Babe Ruth," as he was from Ontario.

●

August Beck & Company of Chicago issued this set in two different styles. Players either posed for studio photo portraits or were depicted in full-length action line drawings that are similar to those used in the Old Judge (N172) set (page 14), although these prints appear more washed out. The Yum Yum Tobacco cards are a unique and rare set, as they were not issued in packs of cigarettes but inserted in the bottom of chewing tobacco tins. The National League is well represented in this set: at least one player from each of the eight NL teams from 1888 had a card, with Ed Greer from Brooklyn being the only American Association player featured in the set.

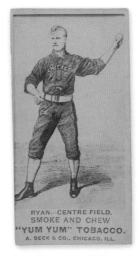

Jimmy Ryan, center fielder, Chicago White Stockings

Billy Nash, third baseman, Boston Beaneaters

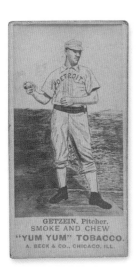

Charlie "Pretzels" Getzien, pitcher, Detroit Wolverines

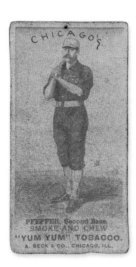

Fred Pfeffer, second baseman, Chicago White Stockings

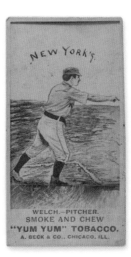

Mickey Welch, pitcher, New York Giants

Welch was one of the original members of the first union for ballplayers, the Brotherhood of Professional Baseball Players. He reportedly did not smoke, curse, or drink hard liquor but was such a lover of beer that he was known to write little ditties about it and recite them in saloons after games. One often-quoted rhyme: "A mug of ale, without question / when drunk on top would aid digestion."

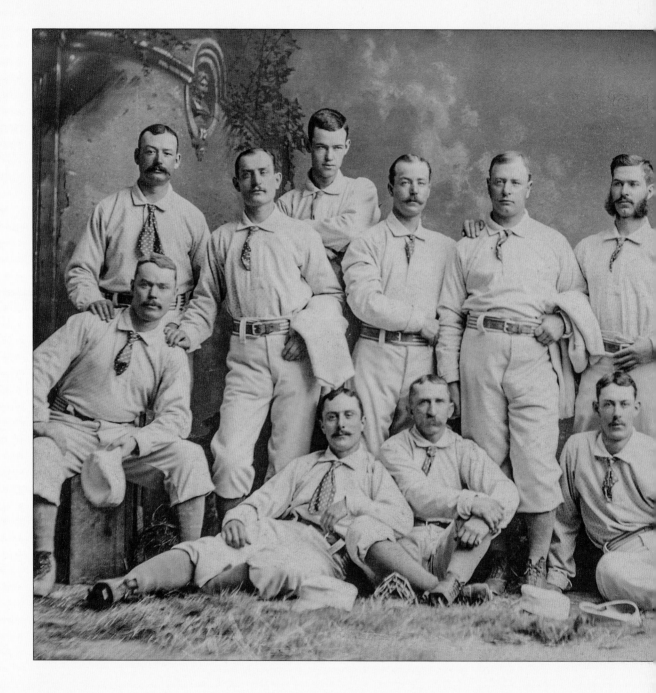

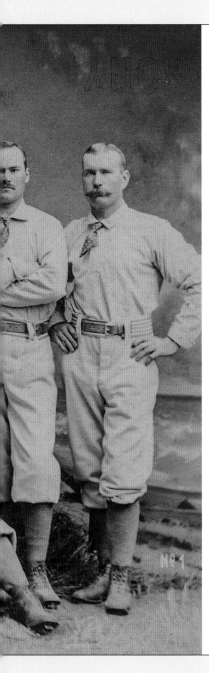

THE BEER AND WHISKEY LEAGUE

Is there an image more redolent of baseball than a ballpark packed with fans sipping cold beer on a warm Sunday afternoon? Just as cigarette packs with baseball insert cards might be said to have had a symbiotic relationship with the growing popularity of baseball, there is no doubt that beer also played a role.

William Hulbert's stern directives prohibiting National League teams from playing on Sunday and forbidding alcoholic beverages at games opened the door to the formation of a new league that would embrace both. In 1880, the National League did not have teams in many populous cities, including New York, Philadelphia, St. Louis, Baltimore, and Washington, all of them filled with German and Irish citizens for whom Sundays were traditionally days to enjoy recreation and patronize local beer gardens. Cincinnati joined the roster of cities without an NL team after Hulbert and his rigidly austere league expelled the Reds for refusing to stop selling beer and playing on Sundays.

The stage was set for the formation of the American Association (AA), also known as the Beer Ball League, in 1881. The new league's owners, many of whom owned local breweries and saloons, brazenly flouted the National League's sanctity, and they capitalized on selling both tickets and suds at AA

"Metropolitan Baseball Nine 1882." Photograph by Napoleon Sarony

The New York Metropolitans were an independent team when this photo was taken. They joined the American Association the following year but folded after the 1887 season. Their name was revived in 1962, when the National League expanded and added a new team, the New York Mets.

"F. Heim & Bro. Brewing Company, Lager Beer, East St. Louis," 1880. Lithograph by Wittemann Bros.

St. Louis was home not only to one of the American Association's charter teams but also to a number of breweries, many of which produced lagers, the style of beer favored by the city's sizable German population and many baseball fans today.

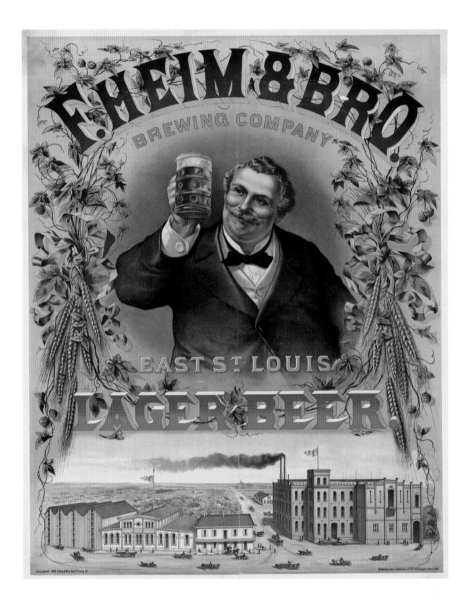

games, which were played on Sundays. The AA also undercut the National League by charging a quarter rather than the NL's fifty-cent standard charge for attendance. Edward Achorn notes in his book *The Summer of Beer and Whiskey* (2013) that the "association pointed away from Hulbert's puritanism to the modern idea of enjoyment at the game" and cites the eccentric owner of the St. Louis club, Chris von der Ahe, as wanting to "welcome working men and fellow immigrants, those who toiled all week and could not break free from their jobs to attend a game."

The National League initially snubbed the upstart, boisterous new league but was eventually forced to reckon with the AA's populist appeal, quality of play, and existential threat to its empire. The two leagues reached a somewhat peaceful coexistence and even jointly hosted what is considered to be the first World Series in 1882. The AA lasted ten years, but in the last three years of its existence, many of its stronger teams jumped to the more stable NL, making it difficult for the league to continue, and when the Players League was formed in 1890, the AA folded. Overshadowed by the National League for much of its existence until its collapse in 1891, the AA was the defiant underdog that stood toe to toe with its more solidly established rival. While the early National League saw many of its stars voted into the Hall of Fame, no player from the American Association was ever elected, thus cementing its place in the realm of baseball obscurity.

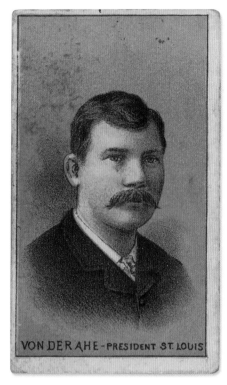

Chris von der Ahe, owner, St. Louis Browns, 1887, Buchner Gold Coins (N284)

A saloon keeper and the owner of the original St. Louis Browns, this eccentric figure was one of the most legendary owners in baseball's early days. He was among the first to lower ticket prices to appeal to working men, and he felt that spectators should be able to imbibe beer and whiskey while watching games at his Sportsman's Park. Von der Ahe was also known to host carnivals with water slides in his ballpark.

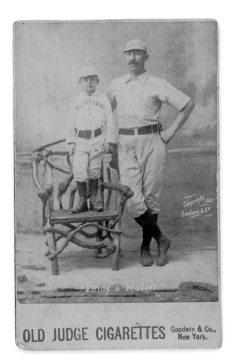

40

Old Judge Cabinets

Goodwin & Company upped the ante for promotional insert cards when it issued its Old Judge Cabinet set, offered as a premium in exchange for coupons distributed in cigarette packages. A pack of Old Judge Cigarettes from 1888 through 1889 contained not only a picture card but also a coupon that read, "On return to us of 25 of the enclosed Slips we will mail you, prepaid, an elegant CABINET PHOTOGRAPH handsomely mounted, of any Base Ball player, in full club uniform, belonging to either the National League, Western League or American Association, that you may select from our printed lists or Editions of Players. These photographs are taken by the instantaneous process, and are an exact representation of the actual position of the players on the field." The photographs, it should be noted, were the same as those found on the smaller Old Judge N172 set (page 14).

Above: William "Buck" Ewing, catcher, New York Giants, with team mascot Willie Breslin

This Old Judge cabinet card features one of the most memorable photographs ever to appear on a card from the nineteenth century. Mascots were like today's batboys, carrying bats and equipment for players, and Ewing thought that Breslin brought him luck.

Right: John Montgomery Ward, shortstop, New York Giants

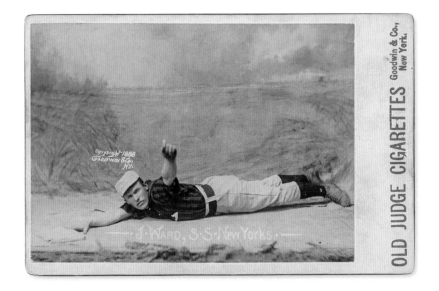

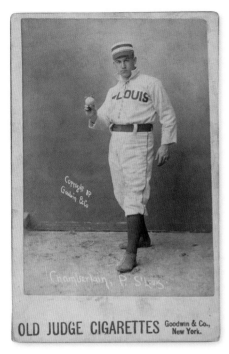

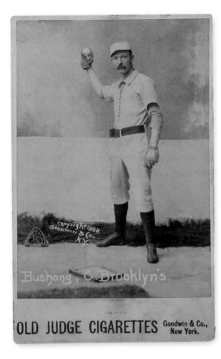

Near left: Albert "Doc" Bushong, catcher, Brooklyn Trolley-Dodgers and Brooklyn Bridegrooms

Brooklyn eventually became the "Dodgers," but in 1888 they were called the "Bridegrooms" because so many of their players were married, which was uncommon for ballplayers in that era.

Below: Mike Slattery, center fielder, New York Giants

Above: Elton "Icebox" Chamberlain, pitcher and outfielder, St. Louis Browns

A cool, calm, and collected pitching style earned Chamberlain the nickname "Icebox" or "Iceberg." He was one of the few players known to pitch with both his left and right arms in a game.

Near right: Scott Stratton, pitcher and outfielder, Louisville Colonels

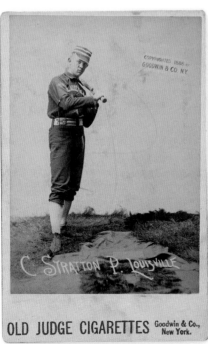

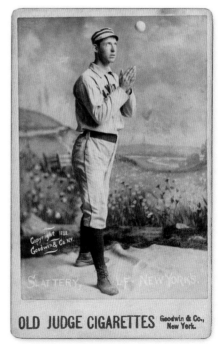

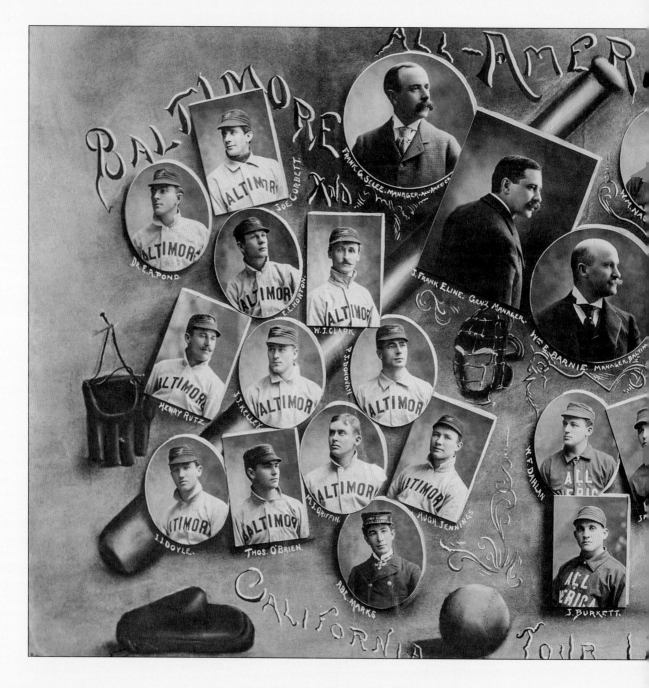

INDUSTRIALIZATION AND BASEBALL

The vast expansion of industry and manufacturing in the nineteenth century led to larger urban populations. Increased industrialization and urbanization in turn contributed to the growth of baseball. As cities thrived, they provided a larger fan base for new clubs, and innovations in mass production and transportation laid the groundwork for the expansion of the national pastime.

A budding middle class, characterized by greater white-collar employment and an improved standard of living, enjoyed more leisure time and disposable income to spend on baseball as both participants and spectators. In contrast, long working hours and low pay did not leave blue-collar workers much time or adequate income to attend games. A few industrialists, seeking to improve worker relations, formed company teams, which were not limited to baseball. Some of the first professional football teams, notably the Green Bay Packers, can trace their roots to these company-sponsored teams.

At the same time, the increase in mass production brought vast improvements in baseball equipment and increased its availability. Enterprising sporting goods suppliers seized on the new market. Leading the

"Baltimore and All-America Base Ball Teams, California Tour," 1897. Photograph by Theodore C. Marceau

In the late nineteenth century, the rapid development of metropolitan hubs and railroads provided ripe conditions for professional baseball to take root. The All-America Base Ball Team was a collection of National League players from various teams who barnstormed across the country.

way was the New York City firm of Peck & Snyder Sporting Goods. Established in 1866, the firm sold bats, balls, gloves, catcher's masks, uniforms, and everything else needed for baseball. Peck & Snyder also distributed advertising cards with pictures of baseball teams on the front, and some claim that these are the first baseball cards ever issued. Soon another upstart entrepreneur, who was also a pitcher for the Chicago White Stockings, opened a sporting goods store with his brother in Chicago.

A. G. Spalding and Bros. became one of the largest sporting goods manufacturers in the country after it bought out Peck & Snyder in 1894 and obtained exclusive rights to supply the "league ball" to both the National League and the American Association.

The spread of professional baseball was also linked to the country's expanding railroad network. Not long after the Civil War, at a Utah ceremony on May 10, 1869, railroad tycoon Leland Stanford drove home the famous golden spike that linked

Cincinnati Red Stockings uniform (left) and hats (right), catalog pages from *Peck & Snyder's Encyclopedia and Price List of All Out and Indoor Sports and Games*, 1873

No. 30. Red Stocking (Cincinnatti,) B. B. Club.

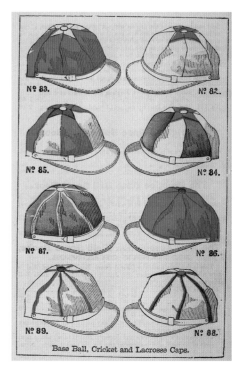

№ 83. № 82. № 85. № 84. № 87. № 86. № 89. № 88.

Base Ball, Cricket and Lacrosse Caps.

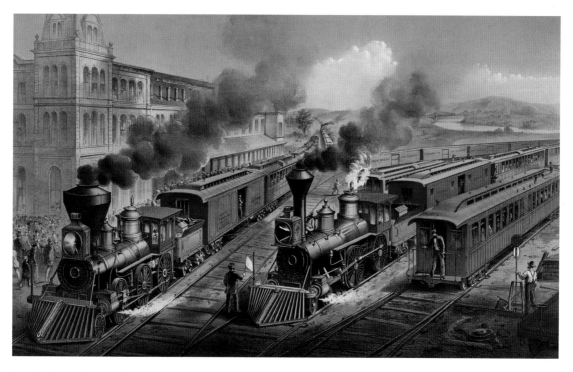

"American Railroad Scene: Lightning Express Trains Leaving the Junction," 1874. Lithograph by Currier & Ives

the Central Pacific and Union Pacific railroad lines, creating the country's first transcontinental railroad. By the early 1870s, more than fifty thousand miles of track crisscrossed the country, making it possible for teams to shuttle from one city to the next to play ball. Long train rides gave idle players time to get in trouble by drinking and playing poker en route to the next town. When the National Association formed, it was not by coincidence that all its teams were based in cities along the early railroad network and within a day's train ride of one another. The expanding rail system made possible the unprecedented tour of Cincinnati's "first nine" (the Reds) in 1869, which included trips to both Boston and San Francisco. Other professional leagues kept an eye on major railroad lines, and game times often were scheduled to coincide with train schedules.

Compared to some of the larger sets of the 1880s, such as the Old Judge (page 14), this S. F. Hess & Company set was relatively small. It included players from four teams: the New York Giants, New York Metropolitans, St. Louis Browns, and Detroit Wolverines. Hess's previous California League set (N321; page 28) was in color, while the cards in this set are sepia-toned photographs. This set is part of a larger series of cards that Hess issued the same year that depicts athletes, actresses, and other celebrities.

Getzien was one of the earliest pitchers to develop an effective breaking pitch, or curve ball, which in his day people called the pretzel curve. Some sportswriters were skeptical at first that it was possible to make a ball move that way and suggested the batters were merely imagining that the ball was curving.

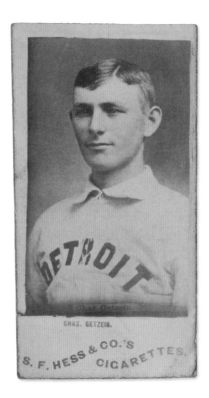

Charlie "Pretzels" Getzien, pitcher, Detroit Wolverines

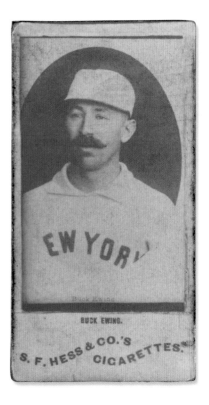

William "Buck" Ewing, catcher, New York Giants

•

Mayo Tobacco Works of Richmond, Virginia, distributed this set in tins of chewing tobacco rather than in cigarette packs, similar to the Yum Yum set (page 35). These cards feature photographs of players mounted on thick cardboard, including a dozen Hall of Famers. The cards reveal variations in how the players' portraits were taken; most show the players in their uniforms, while others show players in their street clothes. Mayo's Cut Plug was one of the last baseball card sets issued in the nineteenth century; the next wave of cards would emerge in the early twentieth century.

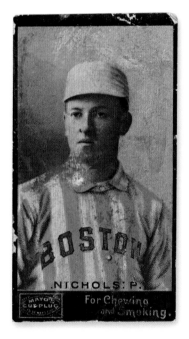

Charles "Kid" Nichols, pitcher, Boston Beaneaters

Completing an incredible 532 games out of the 562 he started during his career, Nichols was one of the nineteenth century's top pitchers.

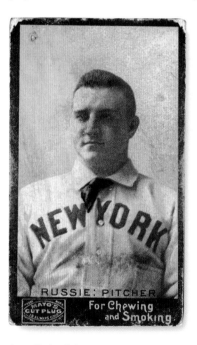

Amos Rusie, pitcher, New York Giants

This Hall of Famer, also known as the "Hoosier Thunderbolt," was probably the hardest-throwing pitcher of the late nineteenth century.

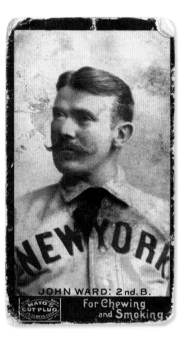

John Montgomery Ward, shortstop, New York Giants

THE GILDING OF THE GAME

Not long after poet and baseball enthusiast Walt Whitman sounded his indicative "barbaric yawp over the roofs of the world" in the poem "Song of Myself" (1855), baseball sounded its own yawp throughout sandlots and ballparks across the country. Fabulists such as Henry Chadwick, Albert Spalding, and Mark Twain were busy spreading the gospel of the game, while crowds swelled to catch a glimpse of the players featured on the tobacco cards they carried in their pockets and saved in scrapbooks.

Baseball's prominence in American life was solidified by the 1880s, when the country was emerging from the economic depression of the previous decade. As the magnates tightened their grasp on the leagues, they tried to polish the image of the sport and appeal to an overlooked population of fans—women. While women had played the game for barnstorming teams in the 1860s, their involvement was something of a novelty that often offended the Victorian sensibilities of the time. The game's reputation for

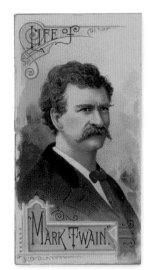

Cigarette card featuring Mark Twain, 1889. W. Duke, Sons & Co., "Histories of Poor Boys Who Have Become Rich and Other Famous People" (N79)

having drunk, boisterous fans, or "rooters," in the bleachers was probably a factor in keeping away wary women. Yet women's status and roles were changing, and by the late nineteenth century, they began openly participating in sports such as tennis, croquet, and cycling. Owners eager to attract women spectators offered "Ladies' Days" at parks to bolster attendance, and hoped their presence would elevate the vulgar tone associated with baseball at the time.

Another new development helped increase baseball's popularity. With the invention of the linotype machine in the 1880s and other improvements in printing technology, the newspaper business was booming. Daily newspapers across the country fought for readers and published sensationalist stories that dramatically increased their circulation. Expanded sports sections also played a role and catered to a public eager for the latest scores and news about the home team.

A May 1886 issue of *Sporting News* stated that "no two professions are so allied together as that of the base ball writer and player," and no writer

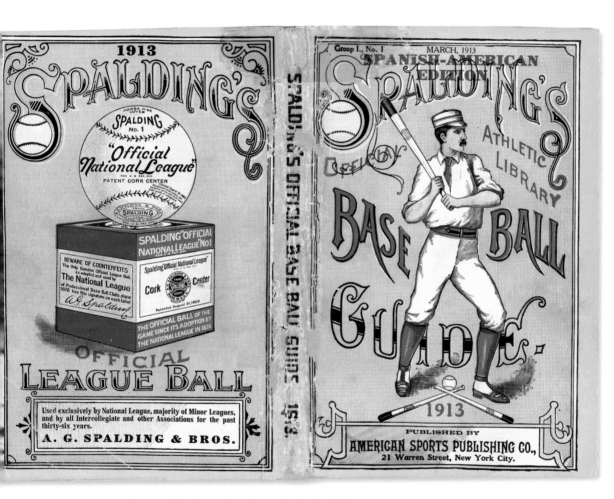

over of the Spanish American edition of *A. G. Spalding's Official Base Ball Guide*, March 1913

supported the game more than Henry Chadwick. Chadwick had immigrated to New York from England in the 1830s and as a young man began covering cricket for local papers. Soon he was championing the new sport of American baseball and developed one of the first guides, *Beadle's Dime Base Ball Player*, which tracked the rules of the game and included statistics and his unique box-score format for keeping score. Chadwick was an early supporter but was also quick to criticize the sport and point out the negative influence of gambling.

The "bugs and cranks," as early fans were called, followed the sport religiously through the guides and newspapers. By the late 1880s,

"Boston National Bloomer Girls' Baseball Club, L. J. Galbreath, originator and owner," 1890–1910

———

"Bloomer girls'" (women's) teams from cities such as Boston and New York traveled around the nation playing local teams. Some teams even had male ringers who wore wigs to disguise themselves.

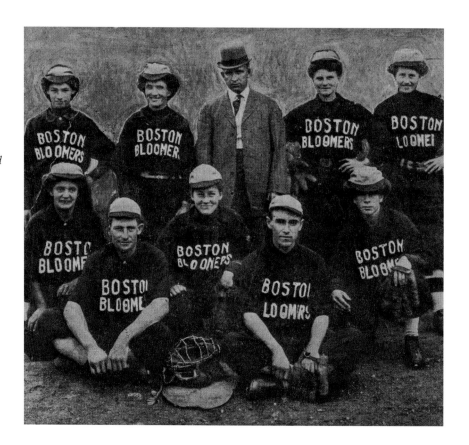

Chadwick became editor of *A. G. Spalding's Official Base Ball Guide*, touted as the official guide of the National League and the written record of the game in the late nineteenth century. It was around this time that the sport became entangled in folktales and misguided stories meant to promote national pride.

After Spalding led a round-the-world tour of exhibition baseball in 1888 and 1889, he hosted a triumphant banquet at Delmonico's steakhouse in New York. Attendees included future president Theodore Roosevelt and Mark Twain, who remarked that baseball was "the very symbol, the outward and visible expression of all the drive and push and struggling of the raging, tearing, booming nineteenth century." After much celebration, and wine, a wave of patriotism swept over the party, some attendees giving speeches that derided any notion that baseball was not a uniquely American creation. Over the ensuing years, Chadwick continued to maintain (correctly) that baseball derived from European children's games, but he was ignored. Spalding and others, meanwhile, propagated the hokum that Civil War general Abner Doubleday had created baseball out of thin air one afternoon in Cooperstown, and many still believe that apocryphal story.

"I'm Baseball Crazy, Too," Curtis Tuttle (lyricist) and Jean Buckley (composer), 1914

———

"The Grand Old Game," F. A. Thole (lyricist and composer), 1909

———

"Slide Kelly Slide!," J. W. Kelly (lyricist and composer), 1889

———

Almost since its inception, baseball has inspired hundreds of songs. As the sport became part of popular culture, still more songs appeared as odes to fans and players alike. Boston's Michael "King" Kelly got his own song about his exploits on the basepaths, while other tunes reflected women's growing presence at games.

A Monopoly
Cuts the Cards

*"Duke," said Ginter, "you couldn't buy us out to save your neck.
You haven't enough money, and you couldn't borrow enough.
It's a hopeless proposition."*

*"Major," said Duke, who had always prided himself on his directness,
"I make $400,000 out of my business every year. I'll spend every cent
of it on advertising my goods as long as it is necessary. But I'll bring
you into line."*

*Exchange between Major Lewis Ginter, owner of tobacco firm
Allen & Ginter, and James B. Duke, owner of American Tobacco Co.,
reported in* Washington Post, *October 15, 1905*

B y the 1890s, many new innovations and public works projects
had vastly improved life in the United States. The steam turbine,
the electric light, and the phonograph were fundamentally
altering the workplace and home, and more modern municipal water and
sewage systems were improving conditions in the cities. At the same time,
the nation, already many years into an agricultural crisis, underwent
a financial panic in 1893 that triggered a five-year-long depression.

A complex web of factors, including falling crop prices and the over-
built, debt-ridden railroad industry, caused a run on currency that shook
the economy to its core. More than four hundred banks and eight thou-
sand businesses collapsed. Unemployment soared to 20 percent in some
places. An earnest Ohio businessman, Jacob S. Coxey, who thought the
government should finance public infrastructure projects to alleviate the
depression, led hundreds of unemployed men on a march to Washington,
DC, in 1894. Though practically ineffectual, Coxey's Army, as the march

Spalding's Official Base Ball Guide. Chicago and
New York: A. G. Spalding & Co., 1889

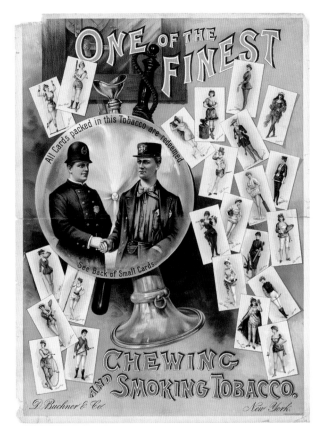

Poster advertising D. Buchner & Co. tobacco, ca. 1890. Lithograph by Donaldson Brothers

This advertisement, which depicts showgirls in costumes suggesting various sports, was typical of how women were portrayed on cigarette cards in the nineteenth century.

came to be called, was emblematic of the labor unrest that was roiling the country and which would spark the massive Pullman railroad strike later that same year.

This was also the age of the industrialists, who formed corporate trusts to control entire industries. John D. Rockefeller of Standard Oil, Andrew Carnegie of Carnegie Steel, and the powerful banker J. Pierpont Morgan held tremendous influence and acted with impunity, as few laws regulated monopolies before the passage of the Sherman Antitrust Act in 1890. Historians Allan Nevins and Henry Commager, in their *Short History of the United States* (1929), noted of the formation of trusts: "The life of the average man, especially if he was a city dweller, was profoundly changed by this development. When he sat down to breakfast he ate bacon packed by the beef trusts, seasoned his eggs with salt made by the Michigan salt trust, sweetened his coffee with sugar refined by the American Sugar trust, [and] lit his American Tobacco Company cigar with a Diamond Match Company match."

Baseball, while not as profitable as steel or oil, had its own hubris- tic magnate. Albert Spalding consolidated his power over professional baseball after the collapse of the American Association in 1891. Baseball in the 1890s consisted of dozens of leagues, but only one could be termed "major": the National League, a twelve-club monopoly that gave owners exclusive territorial rights in large cities and unequaled control over the players. The owners also engaged in cross-ownership that permitted an owner to hold stock in more than one club and freely shift the best players from one club to another. This "syndicate ownership" severely reduced true competition in the sport. Interest and attendance lagged as a result, and by the mid-1890s, with the rising popularity of college football

and horse racing and the "bike boom" of the 1890s, the public's zeal for the national pastime was dwindling.

Monopolies also had a dramatic effect on the production of cigarette cards. A *Chicago Tribune* article in 1889 noted that "cigarettes are of a very similar quality across all brands. . . . buyers pick favorite brands based on the esthetics of the cigarette, making advertising and the esthetic qualities of a cigarette pack essential to maintaining sales." Tobacco baron James B. Duke understood these factors well. In 1889, he spent over $800,000 on ornately designed packaging, colorful cigarette cards, billboards, and painted ads on buildings while simultaneously lowering the price of each pack.

Soon Duke expressed an interest in buying out his competitors, and although he faced some initial resistance, eventually the four major tobacco companies formed a consortium called the American Tobacco Company. Allen & Ginter, W. S. Kimball, Goodwin & Company, and F. S. Kinney received millions in stock, and with Duke's ruthless leadership, they swallowed up most remaining smaller tobacco interests. The American Tobacco Company shortly thereafter claimed 90 percent of all cigarette sales, and the tobacco trust, as it came to be known, became an effective monopoly.

This was the beginning of the end for the first wave of cigarette cards. Because the trust controlled the market, there was far less need for aggressive advertising, and Duke immediately slashed the cigarette-card expense. A June 1890 *New York Sun* article confirmed that "the central object of the trust is to reduce the cost of advertising to a minimum, and as the pictorial card has been the most expensive, it is sure to be curtailed, if not dropped altogether." Before long, the cards all but vanished from cigarette packs.

Saving money was not the only reason the cards nearly disappeared in the early 1890s. Cigarette manufacturers also were reacting to increasingly vocal opposition to the very popular sets of cards, made by Duke and other

"In the Hands of His Philanthropic Friends," by Charles Jay Taylor, *Puck*, March 10, 1897

This magazine cover shows Uncle Sam walking between two bloated businessmen labeled "Monopolies" and "Trusts"; each one is picking a pocket of the blissfully unaware Uncle Sam.

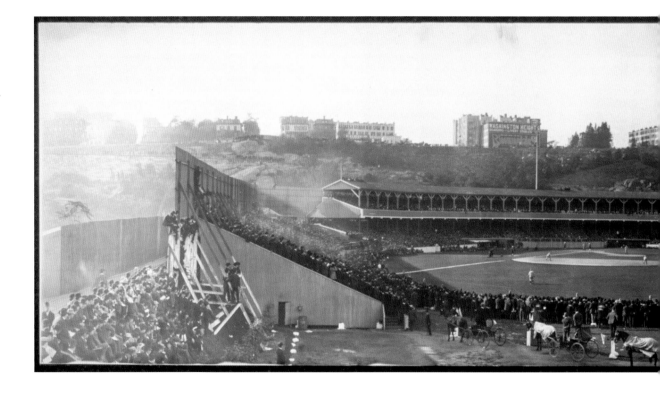

Philadelphia Athletics vs. New York Giants, World Series game, Polo Grounds, New York City, October 1905. Photograph by Pictorial News Company

In the nineteenth century, spectators attended games at ballparks constructed primarily of wood and other cheap, flammable materials, which would routinely catch fire. The Philadelphia, Pittsburgh, St. Louis, Baltimore, Boston, and Chicago ballparks all had fires in the 1890s. This early incarnation of New York's famed Polo Grounds burned to the ground six years after this photograph was taken. Within days of the fire, plans were made to rebuild with stronger materials, and a partially complete Polo Grounds opened in June 1911.

companies, featuring what critics called "disgusting and offensive pictures" of glamorous actresses and generally anonymous women in provocative poses. In *Cigarette Card Cavalcade* (1948), A. J. Cruse quoted an article suggesting the cards were "a form of sexual excitement to induce moral degeneration in the male." There were also reports of film negatives featuring prominent actresses being sold and used for cigarette cards. In 1889, Gracie Wade, an actress from New York City, sued Duke's company for $10,000 in damages for circulating cards featuring her picture without her permission.

The 1890s also marked the beginning of what is now called the Progressive Era, when a wave of

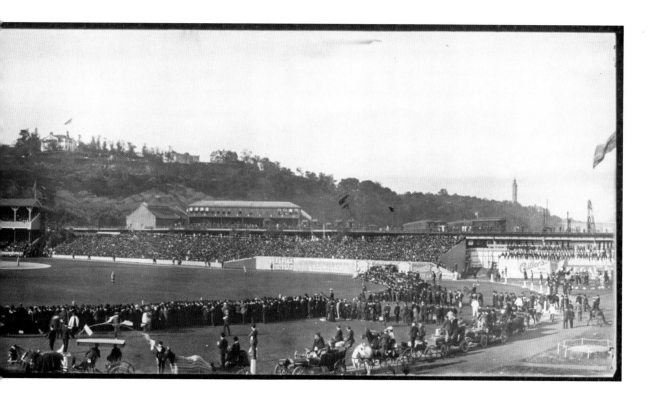

reformers, predominantly led by women's clubs, educators, and clergymen, demanded social change. As calls increased for national women's suffrage, labor reforms, and prohibition of alcohol, antitobacco activists petitioned lawmakers to ban cigarette and tobacco sales. The New York Society for the Suppression of Vice took specific aim at tobacco advertisements and the "indecent pictures" featured on cigarette cards. While some modest local laws were enacted, most of them prohibiting sales to minors, significant legislation outlawing tobacco was never passed. Duke's trust continued unabated, and cigarette sales, with or without the cards, continued to climb.

CIGARETTE PICTURES GOING.

The Harmless and the Nasty, Because They are Too Costly Advertising.

From the Philadelphia Record.

The cigarette picture, with its bizarre colors, has been put on its last legs by the formation of a tobacco trust, composed of all the leading cigarette manufacturers of this country. The central object of the trust is to reduce the cost of advertising to a minimum, and, as the pictorial end has been the most expensive, it is sure to be curtailed, if not dropped altogether.

In the "combine" are the firms that have been the heaviest caterers to that art which appeals most to the youthful taste, but find that the novel philanthropy is too costly. The great question that agitated them was how to stop this picture-giving business. As long as one gave the rest had to do it, too, to keep in the tide of popularity.

New York Sun, June 15, 1890

THE PLAYERS STRIKE OUT

●

There was a time when the National League stood for integrity and fair dealing. Today, it stands for dollars and cents. Once it looked to the elevation of the game and an honest exhibition of the sport; today, its eyes are on the turnstile. . . . Players have been bought, sold and exchanged as though they were sheep instead of American citizens.

John M. Ward, shortstop, New York Giants, 1887

Baseball was not exempt from the broader labor movements sweeping across the nation at the end of the nineteenth century. As industries grew, changed manufacturing methods, and reacted to market forces, laborers formed organizations through which they sought to improve their lot. Declining wages and poor working conditions led to volatile situations such as the workers' strike against the powerful Illinois-based Pullman Palace (Railway) Car Company. Starting in mid-May 1894 and supported by the American Railway Union, led by Eugene Debs, the strike quickly spread to twenty-seven states and territories, bringing much of the nation's railroad traffic to a halt until state and national authorities crushed the strike in July. By the time of the Pullman strike, baseball had already gone through one of its first labor-related upheavals.

When the Civil War ended in 1865, there were few American spectator sports, and it was rare for people to earn a substantial portion of their wages as professional athletes. Within several years, however, an array of sports appeared, presenting new business opportunities, many of them less than legal. While cycling, wrestling, football, and billiards were all growing in popularity, none rivaled horse racing, prizefighting, and baseball. The big three spectator sports owed their burgeoning popularity to factors that Steven A. Riess identifies in *Sport in Industrial America* (1995) as "urbanization and the commercialization of leisure, which had acclimated people to paying for their entertainment." Riess goes on to note that the big three were "all controlled by politicians and their closest business associates, often streetcar owners or professional gamblers."

Irv "Young Cy" Young, pitcher, Pittsburgh Pirates, between seasons, 1909. Photograph by Bain News Service

———

Ballplayers of the late nineteenth and early twentieth centuries made more than most manual laborers, but it was hardly enough for many who, like Young, had to work throughout the offseason to make ends meet. An accomplished pitcher himself, Irv Young was compared to another pitcher whose surname he shared, the legendary Cy Young.

In its early days, professional baseball was an inherently risky business for team owners. Players frequently switched teams, drank to excess, and colluded with gamblers. Negligible gate receipts often made it difficult for hard-pressed owners to pay players, who, in addition to playing, were occasionally called upon to keep accounting records and handle travel plans. These problems caused many teams to fail. With the emerging industrialist model as a guide, National League founder William Hulbert recognized that the key to turning baseball into a profitable business was the control of labor.

By the 1880s, formal business relationships had been established between owners and players. Owners looking to bring down salaries instituted a salary cap and, in an attempt to stop players from jumping teams, a reserve clause that essentially made a player eligible to play only for his current club. The reserve clause, while generally unpopular with players, would become the mainstay of player control until free agency began in the 1970s. Historian Harold Seymour notes that although these measures gave baseball a stability that benefited both players and owners to some degree, "the players had no voice; the owners decided everything."

Given the labor unrest of the period, discord among players seemed inevitable, and John M. Ward was in the right place at the right time to lead them in a full-on revolt against the owners. Not only a talented ballplayer, Ward had also obtained a law degree from Columbia in the 1885 offseason and a political science degree a year later. Citing labor conditions that had "grown so intolerable as to threaten the present organization of the game," Ward threatened that "if the clubs cannot find a way out of these difficulties the players will try to do it for them." The players' simmering resentment exploded in 1890, when Ward, King Kelly, and other top players broke away to establish the Players League, which formed out of the first players' union, the Brotherhood of Professional Base-Ball Players. Featuring an array of star players, the league offered high-quality baseball during the 1890 season.

Yet the insurgent league lasted only one year. Albert Spalding broke them the following season, and the players limped back to the National League. The end of the Players League was far from the end of what Spalding called "the irrepressible conflict between labor and capital," however. Players throughout the early 1900s made various attempts to organize and challenge the magnates. Yet the reserve clause stood, and owners maintained total control of players until former United Steelworkers attorney Marvin Miller negotiated Major League Baseball's first collective bargaining agreement in 1968 and went on to fundamentally alter owner-player relations.

"'Wards Wonders' of the Players League 1890." Team cabinet photograph of the Brooklyn Wards Wonders

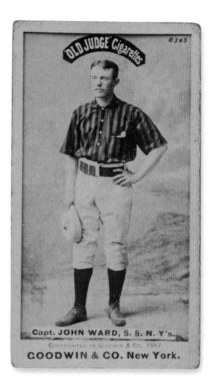

John M. Ward, captain, New York Giants, 1887–90, Old Judge (N172)

The mounted photographs at left show the Players League's Brooklyn team, which was managed and named after league founder John M. Ward. The fans' reaction to the new league was generally positive, as it had plenty of star players, but fan perceptions of the game's underlying labor issues are harder to gauge. While the working class tended to identify more with players as laborers, the press and middle class often resented what they saw as the players' large salaries and did not provide much support to players in their disagreements with team owners.

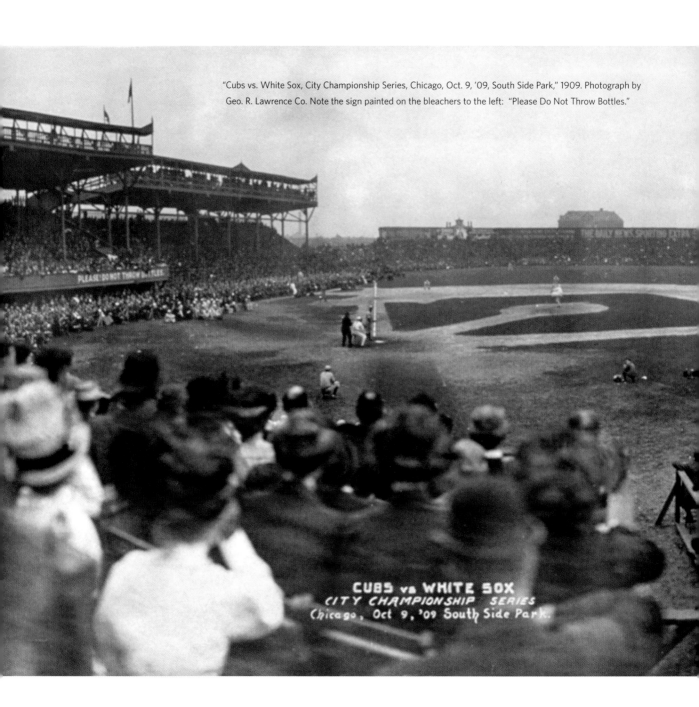

"Cubs vs. White Sox, City Championship Series, Chicago, Oct. 9, '09, South Side Park," 1909. Photograph by Geo. R. Lawrence Co. Note the sign painted on the bleachers to the left: "Please Do Not Throw Bottles."

CUBS vs WHITE SOX
CITY CHAMPIONSHIP SERIES
Chicago, Oct 9, '09 South Side Park.

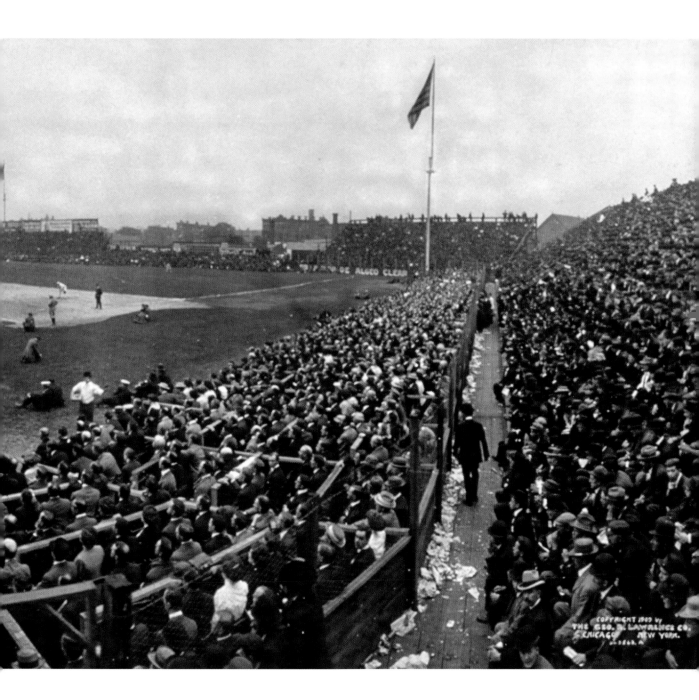

COPYRIGHT 1903 by
THE GEO. W. LAWRENCE CO.
CHICAGO NEW YORK.

A MONOPOLY CUTS THE CARDS

ROWDYISM

●

Mother, may I slug the umpire / may I slug him right away,
So he cannot be here, mother, / when the clubs begin to play?

Chicago Tribune, August 5, 1886

Cigarette cards, with their vivid hues and depictions of handsome players set against luminous skies, may conjure images of an elegant Victorian game that was played in bucolic pastures, but those are mostly illusions. In the rough-and-tumble urban centers where baseball truly developed, the game was anything but tranquil. Newspaper reports as early as 1857 described fans behaving not "as gentlemen should." Many early games descended into bedlam, with fans spilling onto the playing field. Baseball's early supporters, including pioneering sportswriter Henry Chadwick, were concerned with maintaining a certain degree of decorum among spectators. Yet this proved to be a major challenge; many times the players themselves engaged in, and incited, what became known as rowdyism.

By the time the first leagues were formed in the 1870s, the cliché of the ballplayer as the uncouth urban ruffian who guzzled copious amounts of whiskey was well established. "In every point of view he is an eminently undesirable person, and he ought to be peremptorily and completely suppressed," read a *New York Times* editorial on March 8, 1872. Robert Gelzheiser, in *Labor and Capital in 19th-Century Baseball* (2006), contends that, as this view became the prevalent perception of ballplayers, their social status decreased and "the desire to control them increased."

Between the late nineteenth and early twentieth centuries, the game itself went through a variety of rule changes, and players accordingly adjusted their style of play. The bunt and the hit-and-run became tactics teams regularly used to

"Umpiring Made Easy," by James Albert Wales, *Puck's Library*, July 1887

———

The cigarette card may have had an image problem, but by the 1890s, the sport itself had serious troubles, with games often plagued by drunken, unruly fans and players, leading to melees. Umpires routinely needed police escorts to escape furious mobs after games.

counter the dominant pitching, and umpires were shown little mercy as they attempted to call the increasingly chaotic and frequently dirty plays on the field. As renowned baseball historian David Voigt wrote in *American Baseball*, vol. 1 (1966), "To say these were rough times for umpires is an absurd understatement."

Reports of violence directed at umpires by both players and fans were common. An 1884 account from New York's Polo Grounds described a crowd that assaulted an umpire as a "wild and uncontrollable rabble." Owners largely tolerated and even encouraged such behavior by players and fans, for, as Steven Riess notes in *Touching Base* (1980), "Attending baseball games was seen as a safety valve, a substitute for public dissension. Disgruntled workers and clerks could scream all they wanted at the baseball grounds."

Even so, profane and intoxicated fans throwing beer at umpires and games that devolved into donnybrooks did not sit well with many from the upper and middle classes, who still held traditional Victorian values and abhorred what they viewed as a debased sporting culture. From the Bloomington *Pantagraph* in August 1902: "The rowdyism witnessed at the baseball game Sunday deserves the severest rebuke. . . . The fact that it goes on and that a set of drunken men and boys attempt to turn a game into a mob is enough." Even *Spalding's Official Baseball Guide* (1903) noted that disorderly conduct

"The Famous World Beaters St. Louis Browns," 1888. Photograph by F. W. Guerin

"About the toughest and roughest gang that ever struck this city is the nine of the St. Louis Club. Vile of speech, insolent in bearing, they set at defiance all rules, grossly insulting the umpire and exciting the wrath of the spectators" (Sporting Life, *1883*).

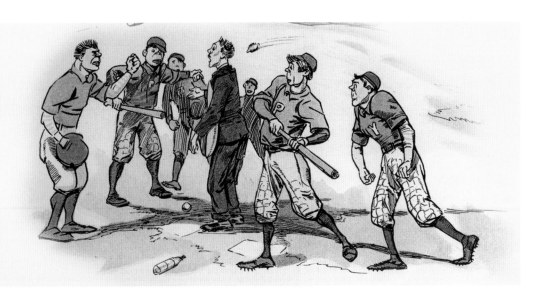

Above: "Wreckreation," by Harry Grant Dart, *Puck*, May 27, 1908

Left: Headline in *Salt Lake Tribune*, August 5, 1906

"BULLDOZE UMPIRE," SAYS TIP O'NEILL

President of Western League Says Ball Players Are Paid to Win Games.

Tribune Special Sporting Service.
CHICAGO, Aug. 2.—President Tip O'Neill, of the Western League, is

Many owners were blamed for deliberately encouraging rowdyism. This report on the president of the Western League, Norris "Tip" O'Neill, would seem to support that claim. O'Neill's extreme views on rowdyism are quoted in the article: "I'd rather see a ball game end in a prize-fight than a love-fest. I'm for rowdyism; I like it. Managers ought to be rowdies. . . . Bulldoze the umpire."

at games drove the "reputable class of patrons from the grandstands by the thousands."

Eventually professional baseball was able to contain rowdyism, due in part to the rise of another major league. In Byron "Ban" Johnson's Western League, umpires were accustomed to more support. When in 1901 Johnson changed the name to the American League and established new teams in the East, he made clear that the league's umpires would be respected and he would not tolerate umpire baiting that led to violence. Although no violent episodes erupted during the first modern World Series, played between Boston and Pittsburgh in 1903, the series was nonetheless a chaotic affair, with police struggling to contain the wild crowds. Lawrence Ritter's *The Glory of Their Times* (1966) includes this description by Pittsburgh outfielder Tommy Leach: "That was probably the wildest World Series ever played. Arguing all the time, between the players and umpire, and especially between the players and the fans. . . . The fans were part of the game in those days. They'd pour

SHIBE PARK 10|8|13

The era of the classic modern ballpark was born when Shibe Park was erected in Philadelphia in 1909. Increased popularity and profits enabled larger concrete and steel structures, including Shibe, to be built. These stadiums were safer, as they were less prone to fire.

right out on the field and argue with the players and the umpires."

Though actual rowdyism is now a thing of the past, even today an umpire can expect hoots and hollers from unruly fans and pugnacious players whenever he blows a close call. Yet umps are no longer in danger of being assaulted. The types of fracases seen at games in the nineteenth century are no longer common. Occasional brawls between teams still occur, and jeering fans can become disorderly. Warren Goldstein, in *Playing for Keeps* (1989), suggests that "the lure of letting go from standards of respectable behavior is too strong to always be resisted. . . . fans who enjoyed large quantities of alcohol, noise, general commotion, and unregulated emotion, have never been banished from the ballpark." The fans' experience at the ballpark has changed, but along with hot dogs, peanuts, and arguing balls and strikes, traces of those rowdier times remain.

Shibe Park, Philadelphia, 1913. Photograph by Bain News Service

IMMIGRATION AND THE NATIONAL PASTIME

The urban American-born men who formed exclusive athletic clubs were the mainspring of many of the first organized baseball teams in the mid-1800s. Soon industrialization and an increased demand for labor began to draw massive numbers of immigrants from Europe to the United States, changing both the nation and the national game. As the new populations flooded into East Coast cities, many immigrant men became baseball players, and many immigrant families became fans. In 1860, a clash between native-born players and immigrants occurred in one of the legendary early series between the white-collar, mostly native-born Brooklyn Excelsior club and the predominantly Irish, working-class Brooklyn Atlantics. The final game descended into a riot between the differing ethnic groups and economic classes.

The millions of Irish immigrants who settled in East Coast cities, Steven Riess notes in *Sport in Industrial America* (1995), "brought a traditional male bachelor subculture that included a lively sporting heritage." Some of these newcomers had children who ended up dominating the ranks of professional baseball by the 1880s. Scanning the box scores of late-nineteenth-century baseball games, one was likely to see names such as O'Keefe, McGraw, Duffy, and Kelly. Despite their increasing prominence in the national game, many Irish players were criticized for their hardnosed playing, and their hardnosed drinking.

There was constant tension between those tied to baseball's upper-class roots and the new immigrant players, many of whom were Irish and German Catholics—tension exacerbated by the nativism and anti-Catholic sentiment that were rampant at the time. Adrian "Cap" Anson of the Chicago White Sox, who had already made bigoted remarks about black ballplayers, was said to have "no use for players with Irish blood in their veins," either. Despite this conflict, baseball in the

"New York—Welcome to the Land of Freedom—An Ocean Steamer Passing the Statue of Liberty—Scene from the Steerage Deck," *Frank Leslie's Illustrated Newspaper*, July 2, 1887

———

The streams of immigrants who arrived on U.S. shores throughout the nineteenth century contributed to the growth of northeastern and midwestern population centers (and, eventually, their baseball teams) and the transformation of the United States into a more urban nation.

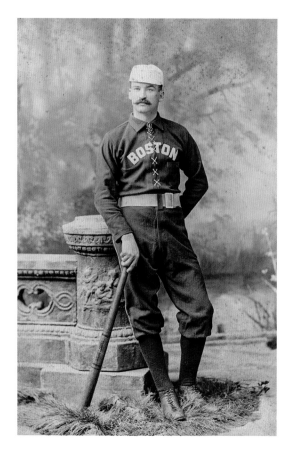

Michael J. "King" Kelly, 1887. Photograph by George H. Hastings

Born to Irish immigrants in 1857, Kelly was part of the first wave of Irish ballplayers. Known for his larger-than-life presence both on and off the field, he was one of the nineteenth century's most popular players.

nineteenth century, as historian Bill James quipped, was "of the Irish, by the Irish, and for the Irish."

Throughout the nineteenth century, Germans made up the largest immigrant group in the United States, although they were slightly less well represented on professional teams. Riess writes, "Germans were somewhat outnumbered by Irish-men in the major leagues, but together they outnumbered the native-born players." German immigrants made significant contributions to the game; German-born entrepreneur Chris von der Ahe, owner of the original St. Louis Browns, was instrumental in founding the American Asso-ciation (1882–91) and bringing the game to his fellow countrymen in St. Louis; John Hillerich, a second-generation German, fashioned a bat in his hometown of Louisville that soon found its way into the hands of most professional baseball "slug-gers," becoming known as the Louisville Slugger.

By the turn of the century, most new immi-gration was coming from Eastern and Southern Europe, a shift only marginally reflected in the makeup of team rosters. Although these new arriv-als were not represented as overwhelmingly in the major leagues as Irish and Germans were in the nineteenth century, they were becoming passion-ate fans of the game. Parents of second-generation Americans might not have understood the game, but their children did, and many tried to find their place in America through baseball. In *The Republic*

for Which It Stands (2017), Richard White contends, "Baseball was the sport where the tangled ethnic, racial, and social tensions of urban America played out most obviously . . . watched by all social classes, who could, at least for the moment, claim a larger identity through the team and the place it represented."

Immigrants were also exposed to baseball cards. James B. Duke, when asked how he adver-tised his cigarettes, remarked, "In every way known to modern business. . . . Every male immigrant who lands at Ellis Island has a package of smoking tobacco put into his hand. He sees the name and remembers it, and when he goes to Texas or Alaska carries the memory with him." By the turn of the twentieth century, immigrants and their children were carrying not just the cigarettes and cards with them, but the game of baseball as well.

William "Germany" Schaefer (left) and Merito Acosta, Washington Senators, ca. 1913–14. Photograph by Harris & Ewing

Born to German immigrant parents, Schaefer was known as a trickster who pulled stunts while running the basepaths. Acosta was part of Cuba's rich baseball tradition.

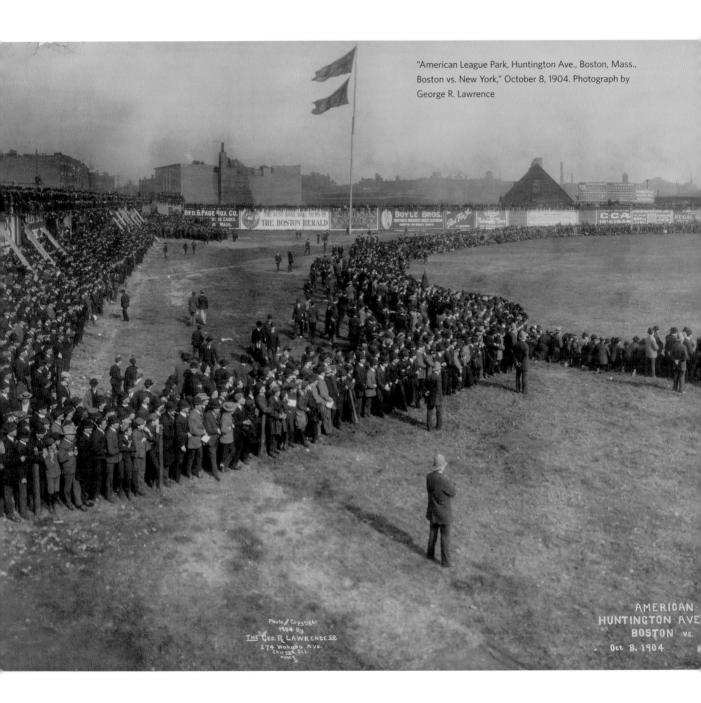

"American League Park, Huntington Ave., Boston, Mass., Boston vs. New York," October 8, 1904. Photograph by George R. Lawrence

The Huntington Avenue ballpark in Boston was the site of the 1903 World Series, and it would have been the site of the 1904 series as well. However, due to fiery manager John McGraw's and Giants owner John T. Brush's ongoing resentment against American League president Ban Johnson, they refused to participate in any postseason play in 1904. This photo was taken at the pivotal October 8 doubleheader in the final regular-season series between the New York Highlanders and the Boston Americans (now the Yankees and Red Sox), where Boston won three of the last four games and captured the AL pennant.

MASS

Chicago Cubs at New York Giants, Polo Grounds, New York,
1908. Photograph by Bain News Service

*Fans were on their feet at the Polo Grounds for
a Cubs-Giants makeup game. It was necessary after
an earlier meeting ended in a tie when teenager
Fred Merkle earned the nickname "Bonehead" for
a committing a baserunning mistake.*

A Trust Busted, a Dead Ball, and the Return of the Cards

1909–1914

There is a strong probability that the next anti-trust manifestation on the part of the United States government will be directed against the tobacco trust. More than any other trust, except the Standard Oil, it is dominated by a single mind, the mind of James Buchanan Duke.

Washington Post, *October 15, 1905*

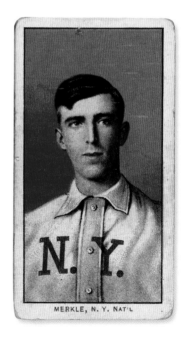

Fred Merkle, first baseman, New York Giants, 1909, White Borders (T206)

During his early days in the tobacco business, James B. Duke once boasted he was "going to do with tobacco exactly what Rockefeller had done with oil." The social and economic impact of trusts and monopolies was a central political debate of the era, however, and just as Duke's control of the tobacco trade reached its apex in the early twentieth century, the tide began to turn. Although previous administrations generally had failed to enforce the Sherman Antitrust Act of 1890, both President Theodore Roosevelt and his successor, William H. Taft, sought to break up business combinations through numerous lawsuits.

In 1902, Roosevelt's Justice Department sued the Northern Securities Company, a railroad trust led by J. P. Morgan. Soon the antitrust surge reached Duke's American Tobacco Company as frustrated farmers and embittered tobacco wholesalers clamored for a level playing field. On July 11, 1907, the *Wall Street Journal* reported that the U.S. government, in its quest to "prevent and restrain" monopolies, had filed a suit in the Circuit Court of New York against the American Tobacco

"The 'Fixed' Umpire," by Louis M. Glackens, *Puck*, June 2, 1909

Glackens's sardonic cartoon illustrates the perceived influence monopolies had over the market and government.

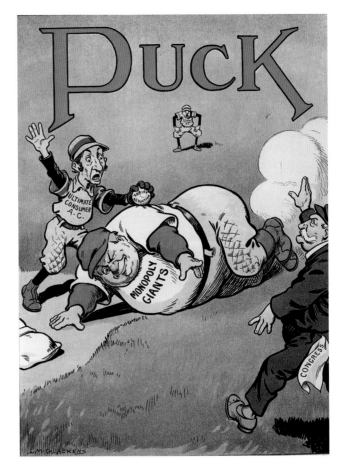

Company. Two years later, a report on the tobacco industry filed by the Department of Commerce and Labor (a precursor to the Federal Trade Commission) declared that the history of the tobacco trust "shows plainly that the leading purpose of the men who have controlled it has been to dominate the tobacco industry."

After almost four years of appeals, Attorney General George W. Wickersham and his special assistant, J. C. McReynolds, successfully argued the case before the Supreme Court, which ordered that the American Tobacco Company be dissolved. Yet the court's decision hardly restored open

markets to the tobacco industry. The complicated structure of the consortium Duke had assembled proved difficult to unravel. As Allan Brandt states in *The Cigarette Century* (2007), "The major players in the Tobacco Trust escaped with the lion's share of assets and the potential to dominate key aspects of the tobacco market, especially cigarettes." He goes on to note that what did occur was a "major intensification of advertising and promotion in the cigarette industry."

In 1909, when the first legal briefs were being filed, Duke understood that it would take years for the case to wind through the court system and that the final outcome could force the breakup of his empire. To soften the effects of such a result, the American Tobacco Company launched a massive advertising barrage clearly intended to shore up Duke's share of the market just as independent New York City firms were starting to import Turkish tobacco blends. As part of that barrage, the second wave of cigarette cards began to hit tobacco shops.

After the trust's dissolution was finalized in 1912, three "new" firms appeared on the scene. Following the lead of the restructured American Tobacco Company, these new firms—Liggett & Myers, R. J. Reynolds, and P. Lorillard—all engaged in aggressive advertising to lure customers, children as well as adults, to buy their products. This new advertising blitz

Outside Shibe Park, October 8, 1913. Photograph by Bain News Service

After the sluggish 1890s, baseball's popularity soared in the early 1900s as new ballparks were built to accommodate growing crowds.

Sportswriters Grantland Rice (center left) and Ring Lardner (center right) standing between President Warren G. Harding (left) and Under Secretary of State Henry P. Fletcher before a golf outing in Washington, DC, 1921. Photograph by National Photo Company

A new generation of sportswriters, with penetrating insight and occasionally mordant commentary, provided fans who could not attend games the inside scoop on the home team.

included coupons for premiums and elaborate card sets. Taking advantage of advances in printing techniques and photomechanical reproduction (called halftone), these firms created some of the most memorable and iconic sets of baseball cards ever produced.

Between the disappearance of baseball cards in the 1890s and the cards' reappearance in the early twentieth century, there were major developments in the game itself. The National League, as the sole major league, seemed doomed at the turn of the century. Lacking the excitement of a World Series, fans turned away from the national pastime, and the magnates were left with slimmer gate receipts. As with the boom-and-bust cycle of many businesses, however, a new competitor proved favorable for the NL. When Ban Johnson's American League moved teams into former National League strongholds, there was some initial acrimony between the leagues. These differences were ironed out in a 1903 agreement that granted the American League "major-league" status. Postseason play resumed as the modern World Series between the two leagues formally began. Over the next decade, attendance at games doubled.

While the game on the field during the early 1900s was healthy, the ball was dead. The so-called Dead Ball Era got its name from the fact that baseballs at the time had a rubber center and tended not to fly far. The era was marked by a lack of home runs, low scoring, and playing for runs one at a time. Some historians question how much the materials used in the actual ball contributed to the scarcity of offense; tough pitching and stellar fielding may have contributed as much to the lower scores as the quality of the ball.

Yet the ball did play some part. Not only was it less lively than today's ball; it was also filthy. Balls seldom were replaced during the course of games, and balls hit into the stands were retrieved and used again. By dusk, dirty balls could be difficult to see, making it particularly difficult to

track a spitball (a notorious pitch in which the pitcher spits on the ball to make it curve or drop). At this time, many players used chewing tobacco, and this, too, contributed to the condition of the ball. As Al Bridwell, Boston's shortstop, relates in Lawrence Ritter's *The Glory of Their Times* (1966), "They had four spitball pitchers on that club, and I had a devil of a time throwing the ball on a straight line from short to first base. The darn thing was always loaded!"

The growth and popularity of baseball during this time owed a debt to increasing coverage in the newspapers. Sportswriter Henry Chadwick, among others, promoted baseball in the press in the nineteenth century, but a new generation of journalists was on the beat by the 1900s. Baseball historian David Voigt notes that these younger writers "departed from Chadwick's stilted style and created the lively, cliché-ridden pattern of reporting that still characterizes this form of American literature." Chief among this new set were master stylists such as Ring Lardner and Grantland Rice, and they had plenty to write about.

A string of exciting seasons and a crop of young star players had driven baseball mania to new heights by the end of the first decade of the twentieth century. Fans flocked to games during the rollicking 1908 season, which culminated in a thrilling pennant race in the NL between New York and Chicago. An estimated forty thousand fans witnessed a game that not only included future Hall of Famers but also featured a base-running blunder for the ages committed by the Giant's Fred Merkle. In a flub later dubbed "Merkle's Boner," Merkle failed to touch second base on a crucial play, costing his team the game and the pennant.

The melodrama of the game, and the controversy surrounding it, made headlines across the country and captivated a nation. Immediately following that wild 1908 season, tobacco companies began issuing cigarette cards again, their reappearance dovetailing nicely with baseball's ascending popularity. In 1909, the American Tobacco Company issued what was to become the defining set of the twentieth century: the delightful and sprawling T206 "White Borders" set. Baseball cards were reborn and became permanently fixed in American popular culture, along with the game itself.

Obak

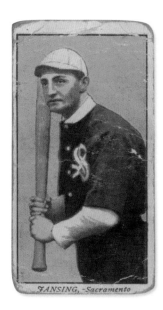

Jansing, Sacramento Sacts, 1909

Olson, Portland Pippens, 1909

Jack Lively, pitcher,
Oakland Oaks, 1910

OBAK, T212, 1909–1911

HALFTONES AND CHROMOLITHOGRAPHS

2.63 × 1.5 INCHES

•

The American Tobacco Company manufactured Obak cigarettes in one of its California factories. To appeal to local baseball fans, the packs included a set of cards featuring players for the Pacific Coast League, one of the premier regional minor leagues. Three Obak card sets were issued over three years, all of them distinguished by the color and style of their lettering and the text on the back, which, for the 1911 set, featured a brief player biography and a few lines of statistics (but not full player names or positions). The Pacific Coast League was very competitive and served as a breeding ground for many future major-league stars. Because of the league's stature, the T212s are one of the largest sets ever issued for a minor league.

It might not have been the major leagues, but while pitching in the Pacific Coast League for Oakland in 1910, the year this card was issued, Lively joined an elite group of pitchers who have won 30 or more games in a single season. That year, he won a remarkable 31 games.

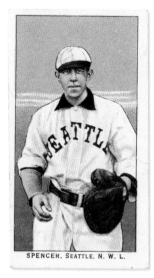

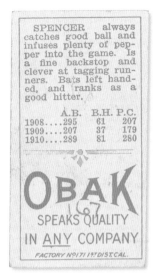

SPENCER always catches good ball and infuses plenty of pepper into the game. Is a fine backstop and clever at tagging runners. Bats left handed, and ranks as a good hitter.

	A.B.	B.H.	P.C.
1908	295	61	207
1909	207	37	179
1910	289	81	280

OBAK
SPEAKS QUALITY
IN ANY COMPANY
FACTORY No 171 1ST DIST CAL.

Bill Brinker, outfielder,
Vancouver Beavers, 1910

Frank Spencer, catcher,
Seattle Giants, 1911

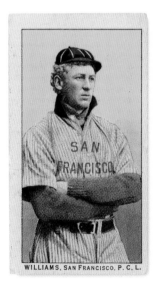

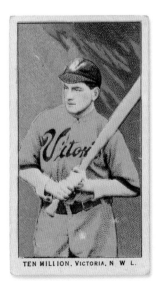

Probably the most peculiar name that ever appeared on a cigarette card is that of the Victoria Bees' Ten Million. Million was the family's surname and, according to Ten's daughter, his first name was a product of his mother's "penchant for the unusual." Unfortunately, his name was more remarkable than his baseball career; he never broke into the majors.

Nick Williams, catcher,
San Francisco Seals, 1910

Ten Million, outfielder,
Victoria Bees, 1911

Ramly Cigarettes

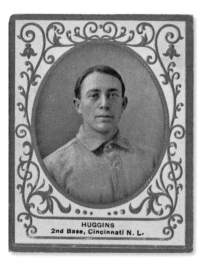

Miller Huggins, second baseman, Cincinnati Reds

This unique set, produced by the Mentor Tobacco Company of Boston, capitalized on the early-1900s Turkish and Egyptian tobacco fad. The cards found in Ramly cigarette packs were black-and-white photographic portraits surrounded by ornate gold-embossed oval frames and decorative gold borders. The elaborately designed cards were also distinct from other sets because they were almost square in shape. While omitting some stars of the era, such as Ty Cobb, Honus Wagner, and Christy Mathewson, the set does include many other Hall of Famers, including Walter Johnson, Willie Keeler, and Charles Albert "Chief" Bender. Due to its unique design and ornate fancy printing, the T204 really stands apart from many other early baseball card sets.

T. H. Murnane, president, New England League

Above: Huggins had a solid career in the majors as a second baseman and made the Hall of Fame. However, he is probably better known as the manager of the great 1920s New York Yankees dynasty, including the 1927 "Murderers' Row" team that won 110 games and featured six future Hall of Fame players, including Babe Ruth and Lou Gehrig.

Left: Born in Ireland around 1855, Tim Murnane was a first baseman and outfielder for some of the first professional teams in the 1870s. After his playing career, Murnane remained very active, first as a sportswriter for the Boston Globe *and later as president of the New England League.*

Henry Homer "Doc" Gessler, outfielder,
Boston Red Sox

Eddie Plank, pitcher, Philadelphia Athletics

Hall of Famer Plank was a wizard on the mound during Philadelphia's dynasty in the early 1900s. A master tactician, Plank did not have the blazing speed of a Walter Johnson, but, as teammate Eddie Collins said, "Plank was not the fastest. He was not the trickiest, and not the possessor of the most stuff. He was just the greatest."

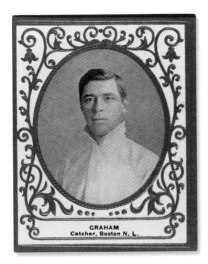

George Frederick "Peaches" Graham, catcher,
Boston Doves

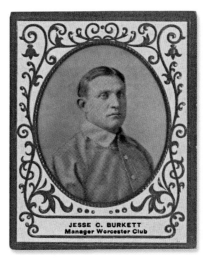

Jesse C. Burkett, manager, Worcester Busters

Before ending up managing the Busters, Burkett had a pretty good run in the major leagues with the New York Giants and later with the Baltimore Orioles. In 1895, he led the NL in batting with a .405 average, and he still holds the career major-league record for inside-the-park home runs with 55.

White Borders

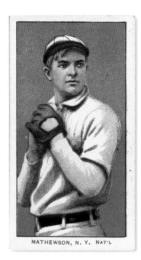

Christy Mathewson, pitcher,
New York Giants

The American Tobacco Company inaugurated the second wave of baseball cards in spectacular fashion when, from 1909 to 1911, it issued the T206 White Borders, the most colorful and expansive card set ever produced. Among the most extensively distributed cigarette card sets, T206 cards were distributed via sixteen cigarette brands, including Lenox, Piedmont, Sweet Caporal, and Uzit. Called "the Monster" by collectors, the set includes nearly 525 color portraits. Printed by the American Lithograph Company of New York, the cards portray players in a variety of ways, including action poses and portraits, and generally cast the players against bold, colorful backgrounds. The portrait cards were based on dignified photos taken by renowned sports photographer Carl Horner in his Boston studio.

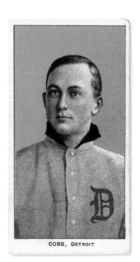

Tyrus Raymond "Ty" Cobb,
outfielder, Detroit Tigers

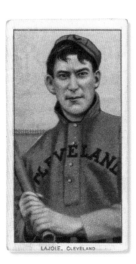

Napoleon "Nap" Lajoie, second
baseman, Cleveland Naps

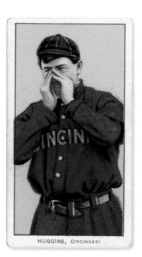

Miller Huggins, second baseman,
Cincinnati Reds

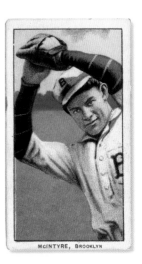

Harry McIntire, pitcher,
Brooklyn Superbas

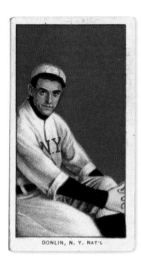

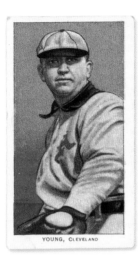

Mike Donlin, outfielder and first baseman, New York Giants

Denton True "Cy" Young, pitcher, Cleveland Naps

William Henry "Willie" Keeler, outfielder, New York Highlanders

Norman Arthur "Kid" Elberfeld, shortstop, Washington Nationals

The vibrant colors and stoic faces of players on cigarette cards give no indication of the gambling, violence, and debauchery that were all too common in the world of baseball in the era when Donlin's card appeared. Although one of the more popular players in his day, Donlin often got drunk and landed himself in jail. After his playing days, he became an actor, even appearing in silent films alongside the legendary John Barrymore.

Cy Young was one of the giants of turn-of-the-century baseball and pitched in the first World Series in 1903. Playing in a time when relief pitching was rare, Young was a workhorse, finishing an astounding 749 of the 815 games he started during his career, which lasted well into his forties. Today, the top pitcher in each league is honored with the Cy Young Award every season.

Despite the diminutive stature that earned Keeler the nickname "Wee Willie," he was one of the game's great hitters. Ogden Nash included Keeler in his famous baseball poem "Line-Up for Yesterday: An ABC of Baseball Immortals" in a stanza that goes, "K is for Keeler / As fresh as green paint / the fastest and mostest / To hit where they ain't."

Sometimes called the "Tabasco Kid" for his aggressive and dirty style of play, Elberfeld epito- mized the tough and gritty early-twentieth-century baseball player. It was said that, after getting spiked by runners when he played shortstop, he would pour whiskey into wounds on his legs to cauterize them.

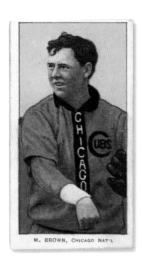

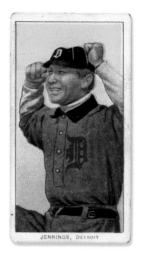

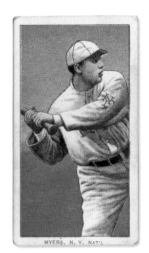

George "Hooks" Wiltse, pitcher, New York Giants

Mordecai Brown, pitcher, Chicago Cubs

Hugh "Hughie" Jennings, manager, Detroit Tigers

John Tortes "Chief" Meyers, catcher, New York Giants

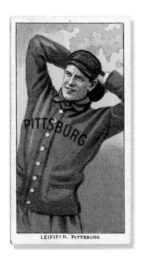

Albert Peter "Lefty" Leifield, pitcher, Pittsburgh Pirates

Called "Three-Finger" Brown after a machine accident severed the index finger of his throwing hand, Brown adjusted to his handicap and even turned it to his advantage. He developed a curveball that broke sharply due to the unique way he was able to grip the baseball.

"Ee-yah!" That cry would come from the dugout when Jennings was manager of the Tigers. He was the skipper of the great Tigers teams of the early 1900s, which included Ty Cobb and Sam Crawford. Jennings took his work seriously, but he also believed in fun—in addition to his distinctive outbursts, he enjoyed hamming it up with both players and fans.

A member of the Cahuilla tribe of California, Meyers was one of the few American Indian professional ballplayers in the early 1900s. The charismatic Meyers was a fan favorite and the primary catcher for Christy Mathewson. One of the best catchers of the Dead Ball Era, Meyers earned the respect of the skipper John McGraw and played an important role on the Giants teams that reached the World Series in 1911, 1912, and 1913.

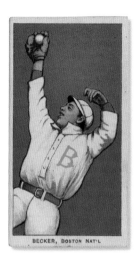

BECKER, BOSTON NAT'L

Beals Becker, outfielder, Boston Doves

Just how dead was the ball in the Dead Ball Era? In 1909, the year this card was issued, Becker was second in the major leagues with six home runs. Compared to statistics from the modern "live ball era," six home runs would be insignificant. Consider that in the 2017 postseason alone, Houston Astro José Altuve hit seven home runs in just eighteen games.

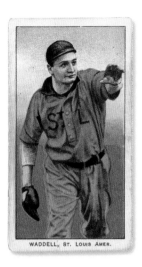

WADDELL, ST. LOUIS AMER.

George Edward "Rube" Waddell, pitcher, St. Louis Browns

Waddell, a southpaw from Pennsylvania, was one of the more eccentric ballplayers of the early 1900s. Off the field, Rube was known to wrestle alligators and disappear for days into towns his team passed through on the road. When he was missing at the start of games in which he was scheduled to pitch, his frantic teammates would often find him under the bleachers, shooting marbles with kids.

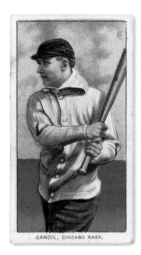

GANDIL, CHICAGO AMER.

Arnold "Chick" Gandil, first baseman, Chicago White Sox

Indicted in the 1919 Black Sox scandal, Gandil often was described as the ringleader who first initiated contact with a gambler named Sport Sullivan and suggested he could help fix the World Series. Though he was acquitted in court, Gandil was banned from baseball for life.

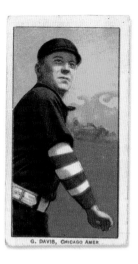

G. DAVIS, CHICAGO AMER.

George Davis, shortstop, Chicago White Sox

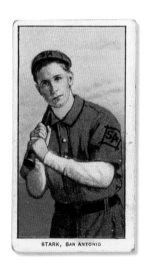

STARK, SAN ANTONIO

Albert "Dolly" Stark, shortstop, San Antonio Broncos

"One of the Ball-Teams Made Up of Boys from Natick Mills," April 17, 1909, Natick, Rhode Island. Photograph by Lewis Hine

Social reformer Lewis Hine's compelling photograph captures young fans of the game as they take a break from a shift at a textile mill to play ball.

KIDS AND THE CIGARETTE CARDS

•

I never smoked a cigarette until I was nine.

H. L. Mencken

Collecting, flipping, and trading baseball cards are rites of passage for many young baseball fans. Yet the seemingly innocent hobby was tarnished by its connection with cigarettes. The streets and alleys of turn-of-the-century American cities were tough places to be a kid. With child labor at its peak around the turn of the century, baseball and collecting colorful baseball cards were instantly appealing diversions for children. Regrettably, so were the cigarettes.

A Bureau of Labor Statistics report stated that between 1890 and 1910, no less than 18 percent of all children ages ten to fifteen worked. At that time, many industrialists and others in American society did not view child labor as problematic. The influential weekly *Niles' Register* claimed that factory work was not for able-bodied men but rather "better done by little girls from six to twelve years old." Invariably, the children who joined the nation's workforce came from families on the lower end of the income scale who were forced to send their young children to work to make ends meet. Children toiled in mines, on farms, in factories and textile mills, and often on city streets, routinely picking up bad habits. It was in this context that the thorny relationship among kids, cigarettes, and cigarette cards played out.

Just as it was a common sight in the cities to see bleary-eyed children emerging from a long factory shift or hawking papers or shining shoes on street corners, it was equally common to see them smoking. Many juveniles developed serious health problems from smoking. The scourge

"'Gimme a Smoke.' Street Boys,"
October 1909, Boston, Massachusetts.
Photograph by Lewis Hine

Even as sales of cigarettes were increasing, Progressive Era reformers were decrying the epidemic of underage smoking. Public schools and doctors across the country tried various approaches to curb the unhealthy habit. Henry Ford became involved in the campaign and even recruited former tobacco endorsers. Ty Cobb provided a quote for one of the widely circulated pieces of antitobacco literature: "No boy who hopes to be successful in any line can afford to contract a habit that is so detrimental to his physical and moral development."

of tobacco use among children was intensified by an industry that directly advertised and sold cigarettes to minors. Boys loitered outside saloons and tobacco shops hounding men for the cards they cherished. In *Mint Condition* (2010), Dave Jamieson writes, "Throngs of children reportedly showed up outside cigarette factories on the weekends, voucher in hand, demanding new albums for their cards."

Wielding his massive advertising budget, James B. Duke had no qualms about explicitly marketing cigarettes to children. A *New York Times*

article from December 1888 noted that cigarette manufacturers frequently offered "premiums that enticed boys to excessive cigarette smoking." A tobacco dealer from the era said that "any Saturday afternoon a crowd of children with vouchers" would besiege tobacco shops, "clamoring for the reward of self-inflicted injury." Duke also used celebrity endorsements from famous ballplayers such as Christy Mathewson and Ty Cobb for his various brands of tobacco products. Allan Brandt writes, in *The Cigarette Century* (2007), that the

tobacco industry "understood what would appeal to boys, the principal target of promotions for collecting and trading. Card collecting tapped into a powerful dynamic in the initiation of new smokers."

Not all child collectors became hooked on cigarettes. The cards were also traded, found discarded in the street, or taken from parents' cigarette packs. Skillful marble "shooters" would win cards in street games, and there were even reports of young entrepreneurs selling cards to other kids. On November 7, 1895, the *Ohio Democrat* wrote of one enterprising businessman named Willie Dreyfus: "His business is the buying and selling of cigarette pictures. . . . He goes around to all the centrally located saloons and gets permission from the proprietor to pick up any pictures which he may find. . . . For new pictures he gets twenty-five cents a hundred. Sometimes he has special pictures which bring as much as one cent apiece."

Protests from alarmed parents and those aligned with temperance leaders and the anti-tobacco movement led many municipalities to enact laws making it illegal to sell tobacco to minors. Many shops ignored the laws, and the cards remained enticing to kids. "We all know the craze of boys for cigarette pictures which they match and trade with," one mother wrote to the editor of the *Washington Times* in 1911. "I am waging a continual war to keep my boys from cigarettes, but they seem to be like the magnet and the Pole."

"Was It an Appreciation?," by Charles Sykes, *Sun*, January 31, 1915

In the early 1900s, sandlot ballgames could be found across the country, as could youngsters searching out and trading cards of their baseball heroes, often pestering strangers for the cards in their cigarette packs.

"The Collecting Mania," by Frederick Burr Opper, *Puck*, April 15, 1891

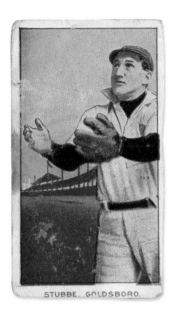

Charles Stubbe, Goldsboro Giants

HALFTONES AND CHROMOLITHOGRAPHS, 2.7 × 1.6 INCHES

HALFTONES, 2.75 × 1.63 INCHES

This set was produced, in two different series, by the Erwin-Nadal Company in Wilson, North Carolina, a subsidiary of the American Tobacco Company. Contained in packs of Contentnea cigarettes, cards in the set depict minor-league players from local teams. The back of each card states that the set features players from the Virginia, Carolina Association, and Eastern Carolina Leagues. The first Contentnea series consisted of color halftone prints, while the second series was composed of black-and-white halftone photographs. The cards contain many errors, probably resulting from the rush to put the set out in order to capitalize on the popularity of the emerging second wave of cards and because minor-league teams were perpetually in flux. The second set likely was issued with black-and-white photographs to keep production costs down; the smaller firm probably could not afford the expense of color lithography. The teams and players included in this set are so obscure that generally only the player's last name and team are shown.

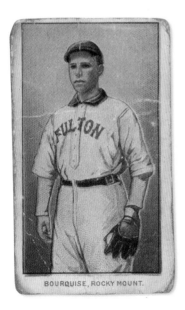

Bourquise, Rocky Mount Railroaders

This card is a great example of the errors that occurred in the set. The name on the card, "Bourquise," does not appear in any baseball database or record book. In addition, the card identifies the man as playing for a team from Rocky Mount, but his jersey clearly says "Fulton," a city in North Carolina that had no baseball team in 1909, the year the card was issued.

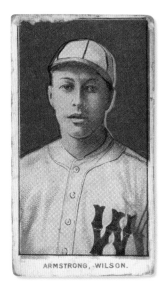

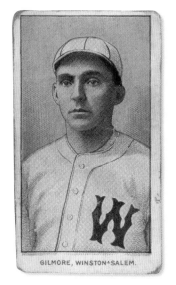

Clearly Gilmore and Armstrong are both wearing the same uniform, but the cards indicate they played for different teams. The "W" on McGeehan's jersey probably stands for Winston-Salem, not Wilson.

Armstrong, Wilson Tobacconists

Hub Gilmore, Winston-Salem Team

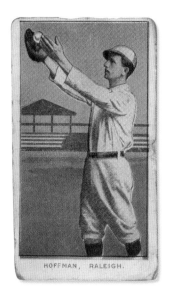

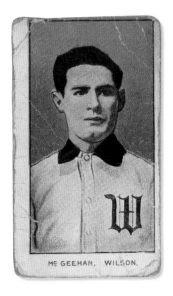

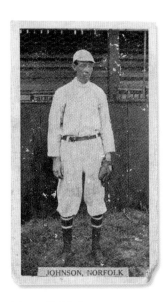

H. H. Hoffman, Raleigh Red Birds

McGeehan, Wilson Tobacconists

Johnson, Norfolk Tars

Domino Discs

The American Tobacco Company issued this set of circular cardboard cards with metal rims. They were manufactured in one factory in New York City and inserted in packs of Sweet Caporal cigarettes between 1909 and 1912. Due to their design, they came to be known as Domino Discs. The set contains 129 players, including many Hall of Fame players such as Walter Johnson, Home Run Baker, Ty Cobb, Chief Bender, Christy Mathewson, and Cy Young. These cards, each about the size of a quarter, were probably meant to be played with or "flipped," a common activity for children.

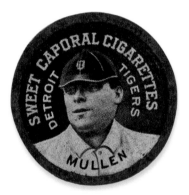

George Mullin, pitcher, Detroit Tigers

Art Devlin, third baseman, New York Giants

Reverse of Devlin disc

"Big George" played the game during an era when pitchers could also be threats at the plate. Mullin's fastball was feared when he took the mound, and he was no slouch with a bat in his hands. He threw the first no-hitter for Detroit in 1912 while also getting three hits and driving in two runs.

Many teams in the Dead Ball Era were a mixture of rural men with little or no education and more urban, college-educated players. Although he left Georgetown University early without a degree, Devlin was initially derided as one of John McGraw's "college boys" when he joined the Giants. A tough player with a short temper, he eventually would earn everyone's respect. As was common during that era, Devlin was also known to tussle with heckling fans in the stands.

The Liggett & Myers Company issued this set of stamps featuring colorful player images with white borders. Based on the earlier Gold Borders (T205) card set (page 108), the company used the stamps to promote its Piedmont cigarette brand. They were printed on an extremely fragile paper stock with perforated edges. Original collectors were supposed to glue the stamps into albums that were offered by Liggett & Myers in exchange for twenty-five coupons. This is the only baseball card set that features players from the short-lived Federal League, which was considered a "major" league from 1914 to 1915.

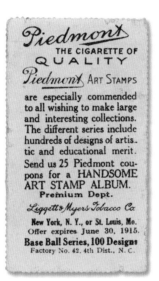

Eddie Collins, second baseman, Philadelphia Athletics. and reverse of card

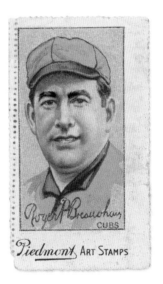

Roger Bresnahan, catcher, Chicago Cubs

Legendary manager John McGraw once said Eddie Collins was "the best ballplayer I have seen during my career on the diamond." One of the greatest players of his era, Collins was instrumental in the Athletics winning World Series titles in 1911 and 1913. In 1913, "Cocky" Collins also won the Chalmers Award, equivalent to today's Most Valuable Player award. He was inducted into the Baseball Hall of Fame in 1939.

In 1907, Bresnahan, a Hall of Fame player, became the first catcher to wear shin guards. "Boy, they sure called me lots of names when I tried on those shin guards," he said. "They must have been a good idea at that, though, because they tell me catchers still wear them."

DEAD BALL DYNASTIES

There was some initial animus between the American and National Leagues at the turn of the twentieth century. By the time they sorted out their differences and postseason play resumed, the game had largely shed the quirks and anomalies that make aspects of nineteenth-century baseball seem so removed from the game of today. The year 1903 marked the beginning of baseball's modern era, as the game reached a new level of refinement and fans flocked through turnstiles in record numbers. The success of baseball in the first decades of the twentieth century was buoyed by a booming economy with increased wages that gave fans more disposable income to spend on tickets to the ballpark.

The early twentieth century brought rule changes and equipment improvements that influenced the character of the game. A larger strike zone, the introduction of the foul strike rule (which counts foul balls as strikes against the batter until the second strike), and improved gloves and field conditions were all factors that worked against hitters. When combined with tough pitching, these changes led to the anemic scoring that marked the Dead Ball Era, when bunting was common and home runs were scarce.

The era was marked by the dominance of winning teams from large cities—including New York, Chicago, Philadelphia, Detroit, Pittsburgh, and Boston—which was largely driven by a fantastic new group of young ballplayers. A baseball-crazed nation seized on these new heroes, including Ty Cobb, Christy Mathewson, Honus Wagner, Frank "Home Run" Baker, Nap Lajoie, and Walter Johnson. Their pictures were everywhere, from cigarette cards to newspapers and magazines. Throngs of adoring "bugs and cranks" could not get enough of these baseball superstars.

Outside Ebbets Field, ca. 1918. Photograph by Bain News Service

Journalist F. G. Lieb penned this tribute to baseball fans in a 1911 issue of Baseball Magazine: *"Who are the foundation of the national game? For whom are a thousand scribes toiling daily and a score of pennants waving proudly in the breeze? The fans. There they are, a great, rollicking, jolly, cosmopolitan crowd, bubbling over with good humor, optimistic, enthusiastic, the living vital force, the motive power of the grandest game the world has ever known."*

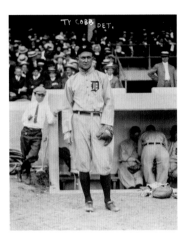

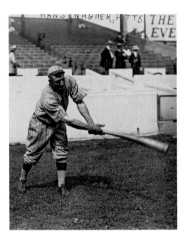

President William H. Taft, 1912. Photograph by Harris & Ewing

Tyrus Raymond "Ty" Cobb, center fielder, Detroit Tigers, 1913. Photograph by Bain News Service

Johannes Peter "Honus" Wagner, shortstop, Pittsburgh Pirates, 1913. Photograph by Bain News Service

As baseball permeated all strata of society, U.S. presidents soon recognized its prominent place on the national stage. On April 14, 1910, President William Howard Taft attended Opening Day and sat near the field in the first row. He threw out the first pitch in front of a packed stadium, starting a new tradition.

In 1906, a wiry young man from Georgia with a fiery temper and a spread-handed batting grip fought his way into the Detroit Tigers' starting lineup, and Ty Cobb remained there for the next twenty seasons. "Baseball is not unlike a war," he famously remarked, and his Hall of Fame legacy includes violent episodes that occurred throughout his career. He hit .320 or better for more than twenty consecutive seasons, including over .400 three times, and his career .366 batting average remains the all-time record.

The son of German immigrants, Wagner grew up in a coal-mining town in Pennsylvania. With his large frame and sharp intellect, he excelled at all aspects of the game. He hit for both power and average and was an amazingly versatile fielder before becoming shortstop for the Pittsburgh Pirates, and some say he was the greatest to ever play that position. The "Flying Dutchman" won numerous batting titles and was the first player to reach 3,000 hits in the twentieth century.

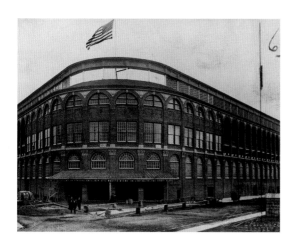

Exterior view of main entrance to Ebbets Field, showing final stages of construction, 1912

Byron Bancroft "Ban" Johnson, Garry Herrman, and Thomas Lynch at the World Series, October 17, 1911. Photograph by Bain News Service

———

After Ben Shibe constructed his new stadium in Philadelphia, other owners began to follow his lead. Soon new, bigger steel-and-concrete ballparks with distinguishing characteristics and pastoral names were being built as "edifices that local residents proudly pointed to as evidence of their city's size and achievement," writes Benjamin Rader in Baseball: A History of America's Game *(2008). Charles Comiskey, owner of the American League White Stockings, erected his namesake ballpark of steel and concrete in 1910. Two years later, Charlie Ebbets bought up lots along Bedford Avenue in Brooklyn and built another of baseball's sacred grounds: Ebbets Field, home of the Dodgers.*

———

Ban Johnson, the American League founder and influential league president, ushered baseball into the new century as he successfully challenged the National League's hegemony. After brokering a peace with the NL in 1902, the "Big Leagues" resumed the popular World Series. Brash, confident, and dictatorial, Ban ran his league with an iron fist while bringing stability to the game as it rose in stature. Branch Rickey once said, "The making or amassing of money was not part of Ban Johnson's life. He lived for the American League and the game of baseball."

102

Nadja Philadelphia Athletics

The Blake-Wenneker Candy Company of St. Louis, Missouri, distributed the Nadja E104-1 set with candy caramels rather than tobacco. Featuring players from only one team, the set commemorated the Philadelphia Athletics' 1910 World Series championship. Each of the set's eighteen cards features a portrait of an Athletics player in the team uniform, which has an A and an elephant on the jersey. The legend "World's Champions 1910" is printed above the player's portrait. The Nadja E104-1 was one of the first sets issued with candy rather than tobacco products, and it foreshowed the shift from cigarettes to gum and candy as the primary means of distributing baseball cards.

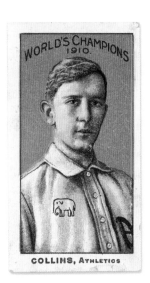

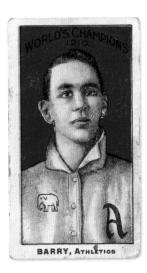

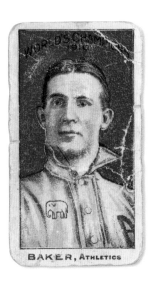

Eddie Collins, second baseman, Philadelphia Athletics

Jack Barry, shortstop, Philadelphia Athletics

Frank "Home Run" Baker, third baseman, Philadelphia Athletics

The Athletics' "$100,000 infield," consisting of Collins, Barry, Baker, and Stuffy McInnis, whose card was not included in this set, was called the greatest infield of all time. Manager Connie Mack gave the group the nickname, in reference not to the players' actual collective salaries but to their perceived value to the team. The four players were a key part of the Athletics' dynasty when they won four pennants in five years between 1910 and 1914. After the 1914 season, Mack, facing pressure to increase his players' pay, sold Collins to the White Sox and Barry to the Red Sox.

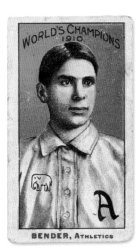

BENDER, ATHLETICS

Charles Albert "Chief" Bender,
pitcher, Philadelphia Athletics

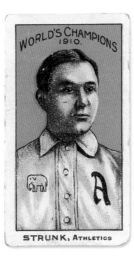

STRUNK, ATHLETICS

Amos Strunk, outfielder,
Philadelphia Athletics

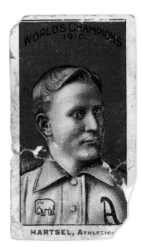

HARTSEL, ATHLETICS

Tully Frederick "Topsy" Hartsel,
outfielder, Philadelphia Athletics

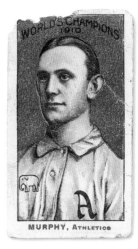

MURPHY, ATHLETICS

Danny Murphy, outfielder,
Philadelphia Athletics

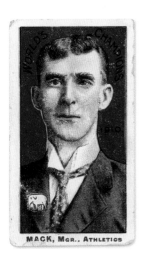

MACK, MGR., ATHLETICS

Connie Mack, manager,
Philadelphia Athletics

Philadelphia was among the best teams in the early 1900s, capturing the AL pennant six times and the World Series three times, in 1910, 1911, and 1913. Known as the "Tall Tactician," the Athletics' manager and part-owner Connie Mack earned the respect of his players with his straight-forward and soft-spoken demeanor in an era when most field leaders employed a more abrasive management style.

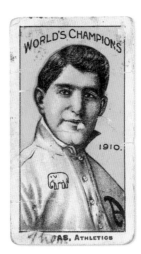

...AS., ATHLETICS

Ira Thomas, catcher,
Philadelphia Athletics

A mediocre player when Connie Mack signed him in 1909, under Mack's tutelage Thomas became the primary backstop for the Athletics' first dynasty, with a keen understanding of pitching strategy. Mack said of Thomas in 1911, "Ira can get more out of a pitcher than any other catcher I ever knew; what he doesn't know about handling pitchers isn't worth knowing."

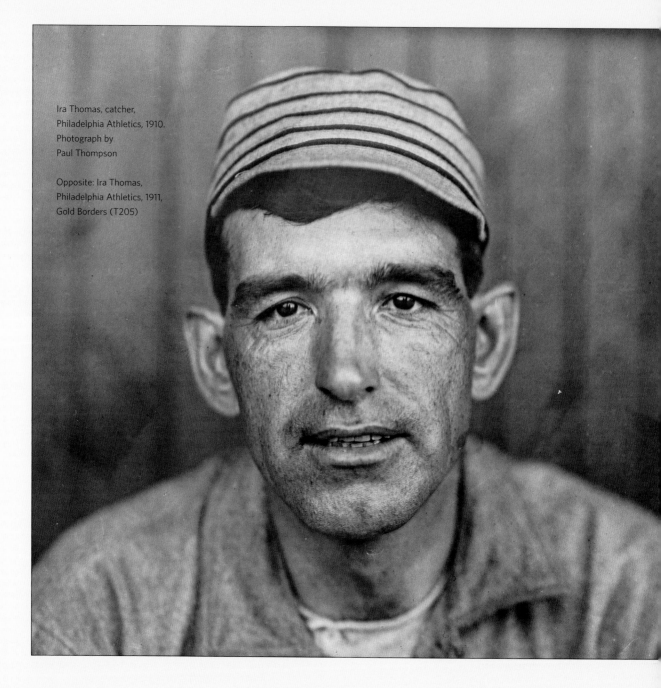

Ira Thomas, catcher,
Philadelphia Athletics, 1910.
Photograph by
Paul Thompson

Opposite: Ira Thomas,
Philadelphia Athletics, 1911,
Gold Borders (T205)

LEGEND OF THE LENS: PAUL THOMPSON

In 1910, a New York City–based freelance photographer named Paul Thompson copyrighted a series of photographs he had taken of baseball players. The intimate portraits are simple, straight-on, head-and-shoulders shots with the players gazing directly into the camera, their expressions often revealing the hard-bitten lives they were leading. Thompson's portraits served as the basis for some notable cigarette card sets issued in the early twentieth century, including the T205 Gold Borders (page 108), the PX7 Domino Discs (page 96), the T202 Hassan Triple Folders (page 124), the T332 Helmar Stamps (page 110), and the T330-2 Piedmont Art Stamps (page 97). Former Library of Congress photography curator Harry Katz said of Thompson's work, "With a shallow depth of field and an unsentimental lens, he brought out in sharp relief the players' leathery faces and steel-eyed stares, capturing their pride, their toughness and the effects of extended exposure in the field. The rough dignity of his portraits survived the translation into color prints on cardboard."

Thompson graduated from Yale University in 1901 and started working on the *New York Evening Sun* as a sports editor, later moving to *Illustrated Sporting News*. His big break occurred after he wrote Mark Twain a letter offering the author his photography services. Twain accepted, and, according to Thompson's obituary in the *New York Times*, the "immediate sale of this set of pictures brought in $1,000, which became the initial capital for the establishment of Mr. Thompson as an independent news photographer." He set up shop in Lower Manhattan with his brother and founded the Article Syndicate Inc., through which he sold photographs to newspapers and periodicals. Tobacco companies also purchased his pictures and used them to create the baseball cards that have preserved his photographic legacy.

Today's major leaguers are swamped with media constantly taking their photographs or interviewing them on camera after the game, but photography in early-twentieth-century baseball was still a nascent enterprise. In Thompson's photos, you can see players with earnest, stern expressions. Here Ira Thomas, a near-smile in his eyes, seems almost bewildered. Perhaps, as team captain, he foresaw his Philadelphia Athletics team going on to win the 1911 World Series.

In the nineteenth century, base-ball cards usually consisted of sepia-toned photos pasted onto the back of cardboard or were created with the laborious hand-drawn sketches of players that were used in lithography. By the 1900s, a new photomechanical technique, called halftone, allowed for faithful re-production of players' photographs. The process involved converting a photographic image into a series of fine dots, producing a vivid color print that simulated the tonality of the original photograph.

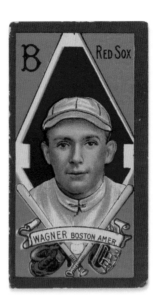

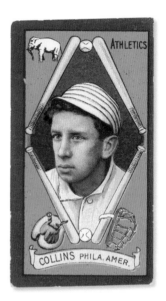

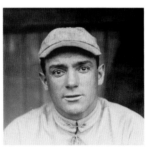

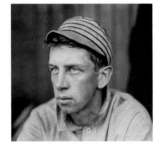

Top: Charles Francis "Heinie" Wagner, Boston Red Sox, 1911, Gold Borders (T205)

Bottom: Charles Francis "Heinie" Wagner, shortstop and coach, Boston Red Sox, 1910. Photograph by Paul Thompson

Top: Eddie Collins, Philadelphia Athletics, 1911, Gold Borders (T205)

Bottom: Eddie Collins, second baseman, Philadelphia Athletics, 1910. Photograph by Paul Thompson

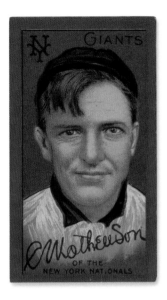

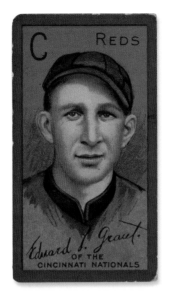

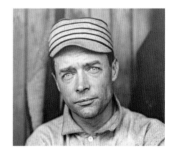

Top: Christy Mathewson, New York Giants, 1911, Gold Borders (T205)

———

Bottom: Christy Mathewson, pitcher, New York Giants, 1910. Photograph by Paul Thompson

Top: Eddie Grant, Cincinnati Reds, 1911, Gold Borders (T205)

———

Bottom: Eddie Grant, third baseman, Cincinnati Reds, 1910. Photograph by Paul Thompson

Top: Harry Davis, Cleveland Naps, 1911. Helmar Stamps (T332)

———

Bottom: Harry Davis, first baseman, Philadelphia Athletics, 1910. Photograph by Paul Thompson

•

108

Gold Borders

The American Tobacco Company issued this set of cards on the heels of its famed T206 set (page 86). The set, named for the cards' distinctive gold edges, depicted both major- and minor-league players. It was one of the first sets to include the players' batting and pitching statistics for the previous three seasons on the back of the cards. The set features two distinct designs. Portraits of American League players are framed by baseball equipment and the teams' insignia. National League portraits are more straightforward: each player appears against a rich color background, and a facsimile of his signature is at the bottom of the card. Both the AL and NL portraits were often based on Paul Thompson's photographs.

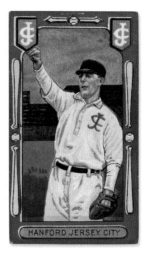

Zach D. Wheat, outfielder, Brooklyn Superbas

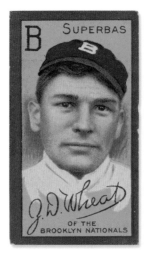

Charles Hanford, outfielder, Jersey City Skeeters

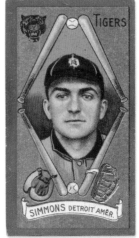

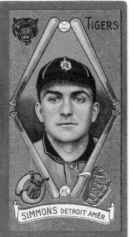

George "Hack" Simmons, second baseman, Detroit Tigers. The back of his card is at right.

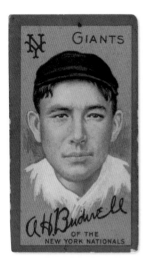

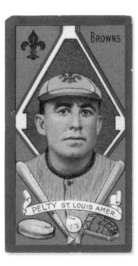

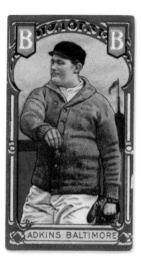

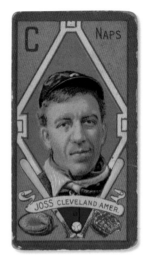

Albert Bridwell, shortstop, New York Giants

Barney Pelty, pitcher, St. Louis Browns

Doctor Merle "Doc" T. Adkins, pitcher, Baltimore Orioles

Addie Joss, pitcher, Cleveland Naps

In Lawrence Ritter's 1966 book The Glory of Their Times, *Bridwell reflects on his time playing ball as a child: "All the kids in the different parts of town had ball teams and we got together and formed a sort of league. The colored teams and white teams started to challenge each other, and before you know it we were playing each other and not thinking a thing about it. Did away with all that trouble we'd had before and brought us all together. . . . I'm not saying baseball did it all. But it helped."*

One of the first Jewish players in the AL and one of the best Jewish players of all time, Pelty was known as the "Yiddish Curver." He ranks just ahead in lifetime ERA of probably the most famous Jewish player of all time, Sandy Koufax. Like Koufax, Pelty was very proud of his heritage.

Adkins deserved his nickname; he became a doctor during his baseball career. After playing major-league ball for several seasons, he landed in Baltimore with the minor-league Orioles, where, in the offseason, he attended Johns Hopkins University, graduating with a medical degree in 1907. Adkins kept pitching for the Orioles and was even known to treat teammates' injuries. Doc was released from the team after the 1912 season.

Known as the "Human Hairpin," Joss was one of the greatest pitchers of the early 1900s. His career 1.89 ERA is the second lowest in major-league history, behind Ed Walsh, whom he once beat by throwing a perfect game (only the fourth ever thrown). Joss's life was tragically cut short the same year this card was issued: he died of tubercular meningitis at age 31. His loss stunned both Cleveland's team and baseball at large.

●

The American Tobacco Company issued this set of stamps with its packs of
Helmar Turkish cigarettes, placing the stamps in glassine envelopes inside
the packages. Each stamp features a black-and-white photograph of a player
surrounded by a colorful baseball-themed frame. The complete set includes
180 baseball players and more than fifty different known frame variations.
Like other sets of cigarette cards, this set features a variety of other subjects
as well. The veteran baseball card historian and dealer Lew Lipset calls
the Helmar stamps "one of the more unusual tobacco-related baseball items
of the twentieth century."

Ross Emil "Tex" Erwin, catcher, Brooklyn Dodgers

Sherwood Robert "Sherry" Magee, left fielder, Philadelphia Phillies

As his nickname indicates, Erwin started his professional baseball career in the Texas League, playing for the Fort Worth Panthers in 1905. After bouncing around the minor leagues for a few seasons, Erwin broke through to the majors when the Brooklyn Dodgers signed him in 1909. As Brooklyn's catcher from 1910 to 1914, he demonstrated the hazards of the position, suffering two broken arms in 1913 when a baserunner collided with him after a hard slide.

A baseball scout relies on a sharp eye, solid baseball acumen, and sometimes simple instinct to follow a promising lead. In 1904, Phillies scout Jim Randall was in a rural Pennsylvania train station when he heard about a kid who played left field for the local semi-pro team. After checking out the game, Randall offered the kid, Sherry Magee, a contract with the Phillies on the spot.

William Denton "Dolly" Gray, pitcher, Washington Nationals

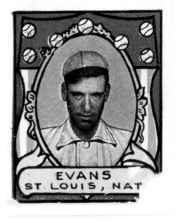

Steve Evans, outfielder, St. Louis Cardinals

Eddie Collins, second baseman, Philadelphia Athletics

Donie Bush, shortstop, Detroit Tigers

Hall of Famer Collins's face was a familiar sight to those who collected cigarette cards in the early 1900s. One of the best players of his era and only the sixth person to join the 3,000-hit club, he appeared in virtually every set issued. This Paul Thompson photograph of Collins (page 106) appeared in three other T-series card sets: the T202s, T205s, and T330s.

Unlike other players who started new careers after their playing days, Bush was a baseball lifer. Once retired, he returned to his hometown and managed the Indianapolis Indians of the American Association from 1924 to 1926, before taking over for the Pittsburgh Pirates in 1927. Bush later had stints with five other clubs, including the Chicago White Sox and Cincinnati Reds, before becoming president and part owner of the Indianapolis Indians.

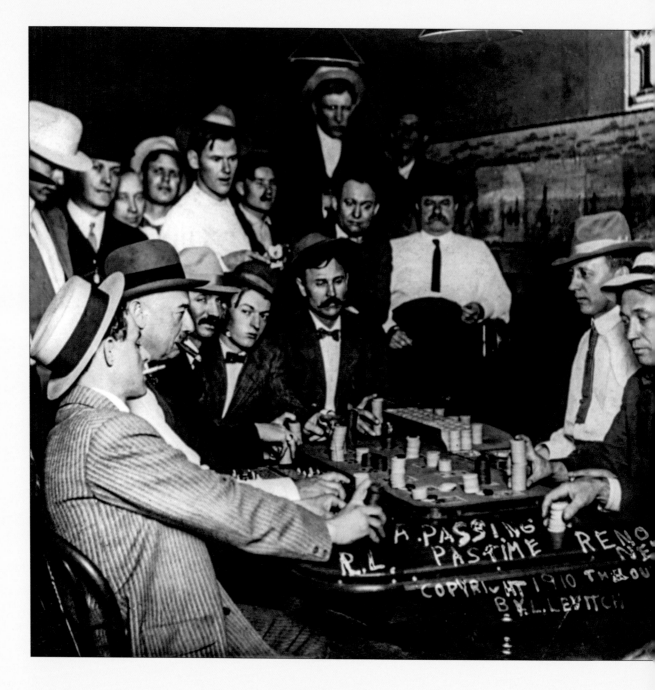

BOOKMAKERS AND BALLPLAYERS

•

To me baseball is as honorable as any other business. It is the most honest pastime in the world. It has to be or it could not last a season out. Crookedness and baseball do not mix.

White Sox owner Charles Comiskey, 1919

America was built by gamblers and risk takers, from the plucky businesspeople who wagered everything they had on a new venture to the unending stream of immigrants who boarded ships bound for an unknown land and future. The burgeoning American culture included a host of gaming activities: backroom card games, riverboat gambling, and wagering on horse racing, boxing, and other sports. Baseball was hardly exempt; in fact, as historian John Thorn states in *Baseball in the Garden of Eden* (2011), gambling was one of the essential ingredients that facilitated the growth of the game: "Sportsmen and sporting men alike loved to gamble, so in this they were united and from this union a national pastime would grow."

Once baseball was able to draw paying spectators, bookmakers moved in, and gambling was soon an intractable part of the game. Both fans and players wagered, and it was not unheard of for a player to place a bet on himself between innings. Fans wagered on everything related to the game: the final score, number of hits, even balls and strikes. Bookies wandered the grandstands adjusting the odds throughout the game, and "baseball pools" (a precursor to modern fantasy baseball) were run out of saloons, barbershops, and pool halls across the country.

As the National League was being formed in the late 1870s, "hippodroming" or "heaving" games was a common problem. Gamblers, seeking to gain an edge, were soon coordinating with players and fixing games.

Open gambling in Reno, Nevada, casinos, 1910. Photograph by L. Levitch

Gambling, especially poker, could have been called the other national pastime in the early 1900s. Bootlegger and racketeer Arnold Rothstein was the power broker behind the Black Sox scandal who supplied the cash to bribe the players. Nine years later, gamblers gunned down Rothstein himself after he failed to pay a $300,000 debt he had incurred during a high-stakes three-day stud poker game.

One of the first major scandals to disrupt professional baseball occurred in 1877, when four players for the Louisville Grays were accused of conspiring with gamblers and throwing some games during a fierce pennant race. Star pitcher Jim Devlin and three others were implicated, and in a hasty punitive decision, league president William Hulbert permanently banned the four players from baseball. Hulbert implored players to "stay clear of anyone known to be tied in with gambling circles. Such practices only detract from the magnificence of our teams."

Although the NL was able to curb the most egregious aspects of gambling and avoided grabbing any major headlines for most of the 1880s, by the turn of the twentieth century, open gambling had largely returned to most ballparks as big-city racketeers angled for their next mark. Ban Johnson, president of the American League, was adamant about erasing any trace of gambling from the national pastime. Yet right under his nose, gamblers infiltrated and tried to fix the inaugural World Series in 1903 despite antigambling

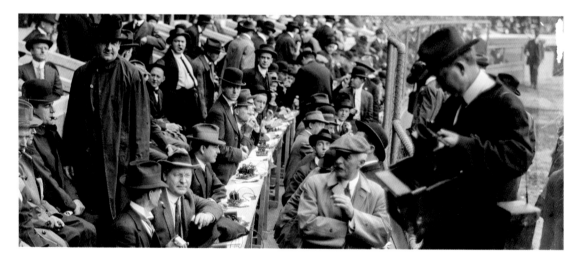

Telegraphers, Polo Grounds, New York, 1910–15. Photograph by Bain News Service

Just as the Internet later helped fantasy-sport participation to grow, the telegraph in the early 1900s made real-time reporting of games across the country possible and made feasible larger gambling operations in taverns, pool halls, and off-track betting parlors in most major cities.

Eight White Sox Are Indicted; Cicotte and Jackson Confess Gamblers Paid Them $15,000

Headline from the *New York Tribune*, September 29, 1920

Edward Victor "Eddie Knuckles" Cicotte, pitcher, Chicago White Sox, 1918. Photograph by Bain News Service

Known for his sharp wit and nasty knuckleball, Cicotte is better remembered for his involvement in the sordid tale of the Black Sox. He broke down in front of the grand jury, confessing to his role in the scandal. "I don't know anyone who ever went through life without making a mistake," he said in an interview a few years before his death.

edicts. Throughout the early 1900s, as gambling continually threatened the integrity of the game, baseball generally maintained the appearance of athletic purity. That façade would soon come crashing down.

In December 1919, just a few months after the Cincinnati Reds had upset the Chicago White Sox in the World Series, Chicago sportswriter Hugh Fullerton published a series of reports about widespread rumors that the series had been fixed. From the *New York Evening World*: "Professional baseball has reached a crisis. . . . In the last World's Series the charge was made that seven members of the Chicago White Sox team entered into a conspiracy with certain gamblers to throw the series." Fullerton's reporting on deals made in hotel rooms among mobsters, gamblers, and ballplayers was

initially disparaged by all sides. Other publications and the owners tried to silence Fullerton. As Gene Carney writes in *Burying the Black Sox* (2007), Fullerton "did not have the power to bring the truth to light."

The coverup started to unravel the following year once a grand jury was called in Chicago to look into gambling issues related to baseball. White Sox pitcher Eddie Cicotte confessed first, and as seven other players were indicted, a few of the gamblers who had coordinated the fix fled the country. At the 1921 trial, all eight were found innocent (yet were still banned from the sport for life), but it was too late. F. Scott Fitzgerald later wrote that "the faith of fifty million people" was destroyed by the Black Sox scandal, as was the sacrosanct image of the national pastime.

116

Distributed by the American Tobacco Company with Mecca Cigarettes, the Double Folders were one of the most inventive cigarette card sets produced. Just as the set's name indicates, the cards were designed to be folded. Two players are included on each card—one is visible when the card is open, another when the card is folded over. The image of a different player was formed by combining it with the bottom half of the front side of the card. The fifty-card set, which features one hundred players from both the major and minor leagues, was also one of the first sets to print players' statistics on the back. Each card shows players from the same team, and the set includes many Hall of Famers. The T201 stands as one of the more attractive and interesting sets; almost fifty years after it was issued, the 1955 Topps Doubleheaders set imitated its classic folding design.

John Evers, second baseman, and Frank Chance, first baseman, Chicago Cubs

Two-thirds of what poet Franklin Pierce Adams dubbed "Baseball's Sad Lexicon" appear on this card; only Cubs shortstop Joe Tinker is missing. Adams's poem describes the three men's double-play combination:

These are the saddest of possible words: "Tinker to Evers to Chance."
Trio of bear cubs, and fleeter than birds,
Tinker and Evers and Chance.
Ruthlessly pricking our gonfalon bubble,
Making a Giant hit into a double—
Words that are heavy with nothing but trouble:
"Tinker to Evers to Chance."

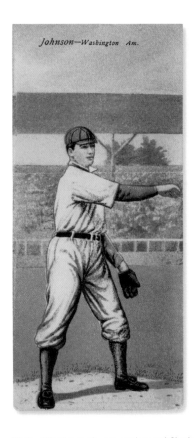

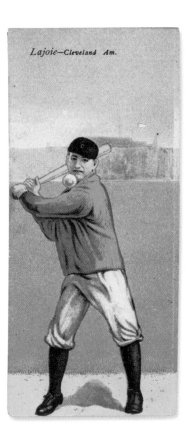

Walter "Big Train" Johnson, pitcher, and Charles "Gabby" Street (not shown), catcher, Washington Nationals

Napoleon "Nap" Lajoie, second baseman, and Fred "Cy" Falkenberg (not shown), pitcher, Cleveland Naps

Pairing Johnson with Street was an astute choice; Street was the Big Train's favorite catcher. He said of Street, "You don't see Gabby's kind of a catcher anymore. He never hit much, but what a receiver he was—big fellow, a perfect target, great arm, slow afoot, but spry as a cat on his feet behind the plate. Gabby was always jabberin', and he never let a pitcher take his mind off the game. When we got in a tight spot, Gabby was right out there to talk it over with me. He never let me forget a batter's weakness."

When Ban Johnson renamed his Western League the American League and challenged the NL's control of the major leagues, Nap Lajoie was one of the first players to jump to the new league. Lajoie was already a star for the Philadelphia team, and Cleveland was so grateful when he signed a contract with their club that they named the team the Naps after him. His stellar career in Cleveland did not disappoint.

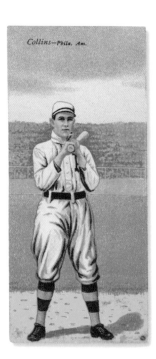

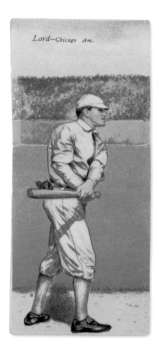

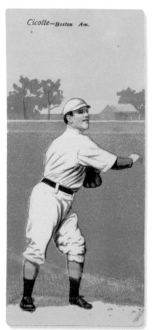

Above: Edward T. Collins, second baseman, and Frank "Home Run" Baker (not shown), third baseman, Philadelphia Athletics

Above center: Orville Woodruff, third baseman, and Otto G. Williams (not shown), shortstop, Indianapolis Indians

Above right: Harry D. Lord, third baseman, and Patrick Henry "Patsy" Dougherty (not shown), outfielder, Chicago White Sox

Right and far right: Edward Victor "Eddie Knuckles" Cicotte, pitcher, and John Thoney, outfielder, Boston Red Sox

The artistry behind many of the nineteenth- and early-twentieth-century chromolithograph tobacco cards is unmistakable, and in no set is this more evident than the Turkey Red Cabinets. Much larger than the standard tobacco cards, this premium set, issued by the American Tobacco Company, could be secured in exchange for coupons distributed in Turkey Red, Old Mill, and Fez cigarette packages. The set featured a hundred players, and many of their poses are identical to those used in the T206 series (page 86), although the image is cropped due to the card's smaller size. The deep, lush colors of these gorgeous cabinet cards, surrounded by a decorative frame, led many people to tack them on their walls as works of art. The vivid, detailed imagery would often cast players against a soft-focused skyline replete with billowing smokestacks or bleachers packed with fans, evoking the aura of nineteenth-century cities.

119

Turkey Red Cabinets

William Thomas "Sleepy Bill" Burns, pitcher, Chicago White Sox

Burns pitched one season for a team with which he would eventually have a much more notorious connection. In 1919, he was an envoy between powerful gamblers and Chicago White Sox players during the fixing of the World Series. Burns later testified, "I told them I had the hundred thousand dollars to handle the throwing of the World Series. I also told them that I had the names of the men who were going to finance it."

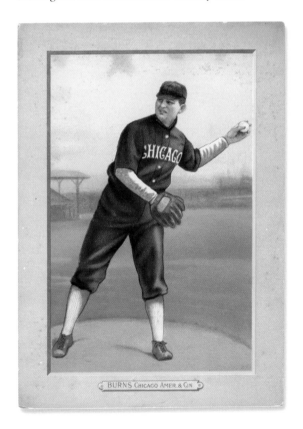

Turkey Red Cabinets

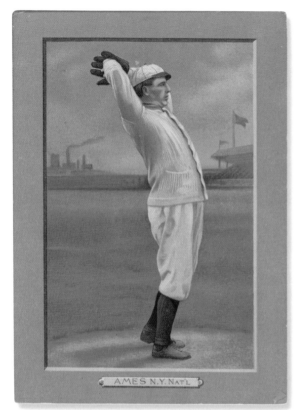

Leon Kessling "Red" Ames, pitcher, New York Giants

While the fastball has always been an intimidating pitch, the curveball has been the most mysterious. With a flick of the wrist, a talented pitcher can make the ball seemingly drop off a table as the batter attempts to hit it. Red Ames, though wild at times, had one of the more devastating curves of the Dead Ball Era. Sporting Life *wrote of him in 1906, "Players say no man who holds a place in the pitcher's box is able to curve the ball so far as he can."*

Art Fromme, pitcher, Cincinnati Reds

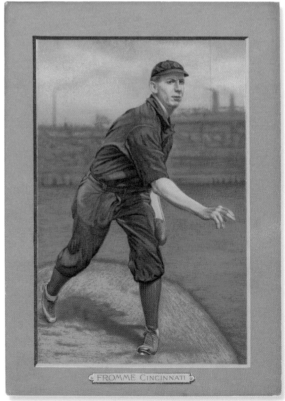

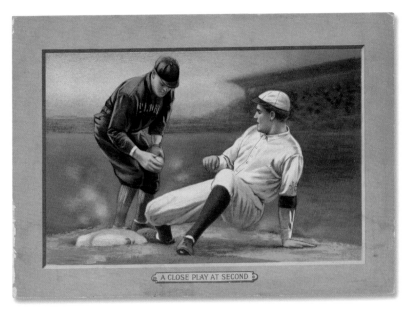

"A Close Play at Second"

The Turkey Red Cabinets set included seven multiplayer action sequences, including these two, another unique feature of this set. Specific players were not identified on the action cards, but the source images for these lithographs were photographs appearing in sporting supplements and magazines of the time, so the scenes depicted were probably pivotal plays in real games.

"Safe at Third"

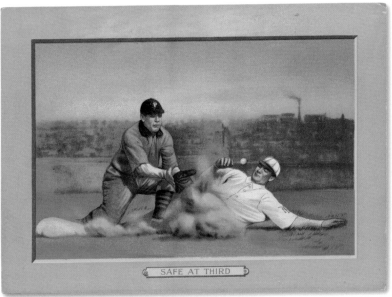

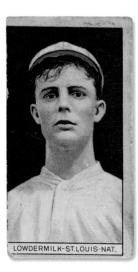

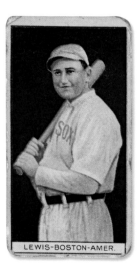

Louis Lowdermilk, pitcher,
St. Louis Cardinals

Duffy Lewis, outfielder, Boston
Red Sox

Brown Backgrounds

The American Tobacco Company followed up its
impressive T206 and T205 (pages 86 and 108) with
another large set of ballplayer cards. Compared to
the previous sets, the T207 might have been somewhat
of a letdown since it did not include stars such as Ty
Cobb and Christy Mathewson. The set is also less attrac-
tive than its colorful predecessors. Its name derives
from the drab chocolate-brown background behind
each player portrait, and the portraits themselves are
awkwardly rendered. A small rectangle on the front of
each card gives the athlete's last name, the name of his
team's city, and the team's league. The back of the card
features a short biographical write-up about the player.

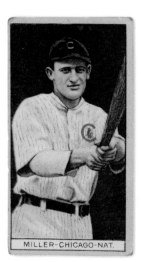

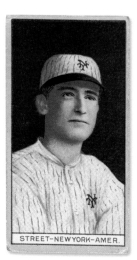

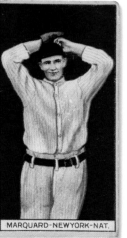

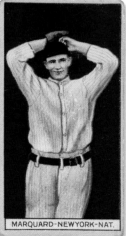

Ward Miller, outfielder,
Chicago Cubs

Charles "Gabby" Street, catcher,
New York Highlanders

Richard "Rube" Marquard,
pitcher, New York Giants

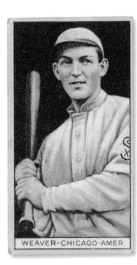

WEAVER-CHICAGO-AMER.

George "Buck" Weaver, third baseman, Chicago White Sox

Although implicated in the Black Sox scandal in 1919, Weaver always maintained his innocence, and his strong statistics for the series seem to bolster his argument. Besides never booting a ball in the field, he hit .324 for the series. Yet he was banned for life with the seven other accused players. Buck's supporters are still trying to clear his name.

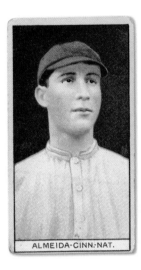

ALMEIDA-CINN.-NAT.

Rafael Almeida, third baseman, Cincinnati Reds

Almeida and Armando Marsans were the first Cubans to play in the major leagues. As a teenager, Almeida had played in the Cuban leagues. In the winter of 1908, the Reds played a few games in Cuba, liked what they saw in Almeida and Marsans, and signed both players. Due to racial attitudes of the time (all major-league players were white), the two Cubans were forced to downplay their heritage.

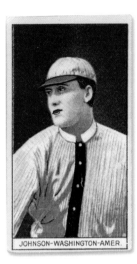

JOHNSON-WASHINGTON-AMER.

Walter "Big Train" Johnson, pitcher, Washington Nationals

Johnson was one of the most famous and dominant pitchers of all time, with a lifetime 2.17 ERA and an incredible 531 complete games in 666 starts. Ty Cobb recalled Johnson's fastball as "just speed, raw speed, blinding speed, too much speed."

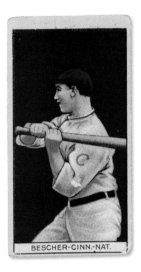

BESCHER-CINN.-NAT.

Robert "Bob" Bescher, left fielder, Cincinnati Reds

Bescher was far and away the best base stealer in the NL and Ty Cobb's closest rival in that aspect of the game. Stealing bases was an important part of the sport during the Dead Ball Era, when hit-and-run plays and bunting were key to winning.

124

Hassan Triple Folders

Hassan cigarettes were a brand manufactured by the American Tobacco Company to counter the products of new upstart firms that were importing Turkish tobacco. Expanding on the concept of the Mecca Double Folders (page 116), this set was composed of triple-fold cards similar to triptychs. Each Hassan pack held a card with the ends folded over the center; when opened, the card showed a black-and-white action photograph flanked by color lithograph portraits of two different players that are almost identical to the portraits on T205 cards (page 108). The center-panel photograph sometimes featured one of the players flanking the photo. The cards, which had short player biographies on the backs, featured many Hall of Famers on multiple cards; Ty Cobb, for example, appeared on several T202 cards, each with a different center photograph.

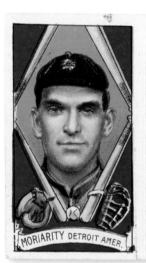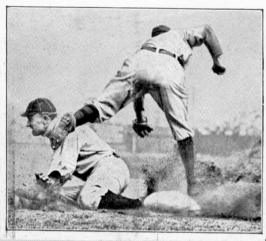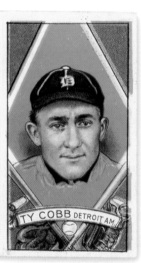

George Moriarty, third baseman, and Tyrus Raymond "Ty" Cobb, center fielder, Detroit Tigers, 1910

The center panel, showing Cobb sliding hard into third base, is one of the most iconic baseball photographs of all time. Charles Conlon, who took the photo during a 1910 game, later remembered, "The strange thing about the picture is that I did not know I had snapped it. I was off third, Cobb was on second with one out, and the hitter was trying to bunt him to third. . . . Cobb started. The fans shouted. Jimmy [Austin of the New York Highlanders] turned, backed into the base, and was greeted by a storm of dirt, spikes, shoes, uniforms—and Ty Cobb. I said, 'Now there's a great picture and you missed it.' I took out my plates and developed them. There was Cobb stealing third. In my excitement, I had snapped it, by instinct."

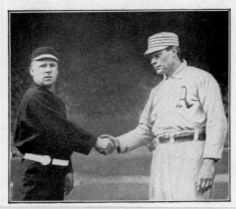
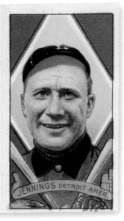

John J. McGraw, manager, New York Giants, and Hugh "Hughie" Jennings, manager, Detroit Tigers

The back of this card accurately calls McGraw one of the "cleverest leaders in the national game." He was a master technician of the Dead Ball Era, with its slower style of play featuring the sacrifice bunt and hit-and-run. His attention to detail and strategy made him one of the game's first great managers, along with Jennings, who was Detroit's skipper.

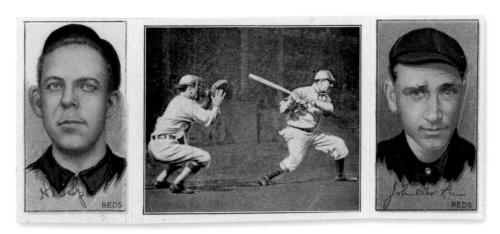

Harry L. Gaspar, pitcher, and John B. "Larry" McLean, catcher, Cincinnati Reds

Hassan Triple Folders

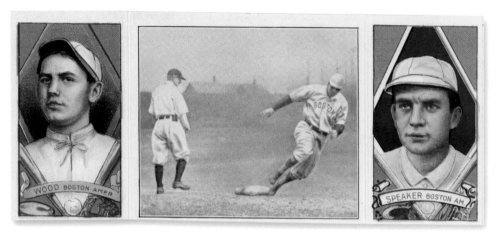

Howard Ellsworth "Smoky Joe" Wood, pitcher, and Tristram Edgar "Tris" Speaker, center fielder, Boston Red Sox

The year this card was issued, Wood had one of his best seasons, winning 34 games while losing only 5 and carrying an ERA of 1.91 while striking out 258. It was also the first season the Red Sox played at Fenway Park, now one of the oldest and most famous ballparks in the majors. Speaker was probably the greatest center fielder ever to guard Fenway's notorious "Triangle," an area of center field where the wall juts out to 420 feet, the deepest part of the park.

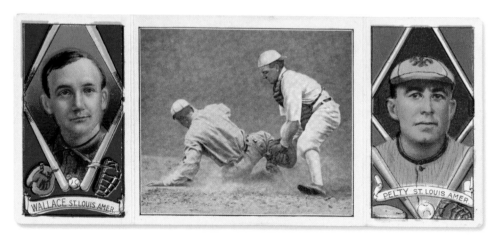

Roderick John "Bobby" Wallace, shortstop, and Barney Pelty, pitcher, St. Louis Browns

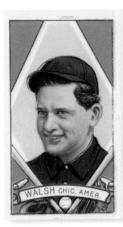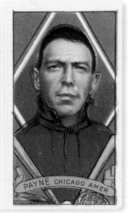

Edward "Big Ed" Walsh, pitcher, and Fred Payne, catcher, Chicago White Sox

Pitching is one of the most grueling positions in the sport. That was especially true during the Dead Ball Era, when pitchers were called on to throw many more innings than they do in the modern game. Walsh was probably the greatest pitcher of the early 1900s—his 1.82 is still the record for lowest career ERA—but he paid a price for his prowess. Said Walsh, "I could feel the muscles grind and wrench during the game. My arm would keep me awake till morning with a pain I had never known before."

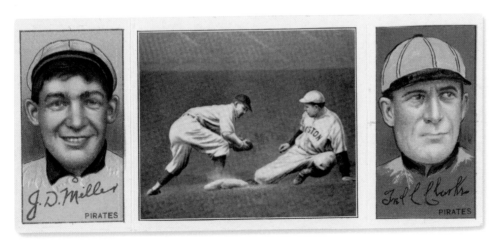

John Barney "Dots" Miller, second baseman, and Fred T. Clarke, outfielder, Pittsburgh Pirates

Issued with Honest Long Cut and Miners Extra tobacco brands, the Series of Champions is technically a multisport release that harkens back to nineteenth-century card sets. Similar to the N28 World's Champion Series, produced by Allen and Ginter (page 4), and the N184 Kimball set (page 34), the T227 also features golf, boxing, boating, track and field, swimming, billiards, and other popular sports. It includes only four baseball players, but all are Hall of Famers. The card's design, with a color image of the player surrounded by a white border, is similar to that of the T206 cards (page 86), although, unlike that set, the reverse of each T227 card includes a lengthy player bio. The T227s are slightly larger than standard cigarette cards and close to the size of modern bubble-gum cards.

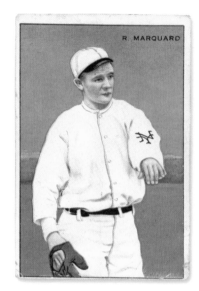

Richard "Rube" Marquard, pitcher, New York Giants

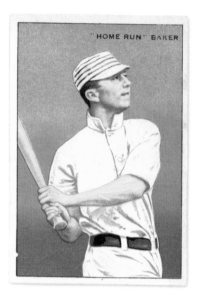

Frank "Home Run" Baker, third baseman, Philadelphia Athletics

A city slicker from Cleveland, Marquard received the "Rube" moniker because he resembled another left-handed pitcher named Rube Waddell. While he was pitching with the Giants, Marquard, like many other ballplayers, joined a vaudeville act to earn extra money. He started performing with singer, dancer, and actress Blossom Seeley, and the two became a regular act and later married. The marriage did not last, however; Marquard returned to baseball, and Seeley stayed in show business.

Baker earned his nickname at a time when baseball seasons did not include many home runs. When Philadelphia's Shibe Park (later Connie Mack Stadium) opened in 1909, it was said that the park was so big that no ballplayer was strong enough to hit the ball over the fence. In Baker's first game, he launched one over the fence and onto the porch of a house across the street, becoming the first player to hit a home run in this legendary ballpark.

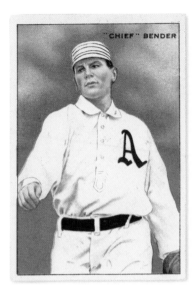

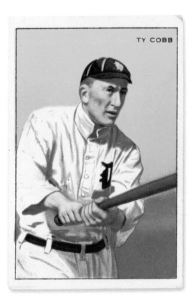

Charles Albert "Chief" Bender, pitcher, Philadelphia Athletics

Tyrus Raymond "Ty" Cobb, outfielder, Detroit Tigers

Philadelphia Athletics owner and manager Connie Mack first noticed Bender when, playing for a semi-pro team in 1902, Bender beat the Chicago Cubs in an exhibition game, a feat that landed him in the majors the following year. Bender was pivotal in the Athletics' World Series victories in 1910, 1911, and 1913, winning five of his seven starts. Called "Chief" for most of his career, Bender generally dealt with insensitive, demeaning stereotypes and insults regarding his American Indian ancestry with aplomb, but he often signed autographs "Charles Bender."

Although many sportswriters portrayed Cobb as a complicated antihero, the headlines he grabbed during his playing days paint a much darker picture. On May 3, 1919, the Chicago Defender, *a prominent black newspaper, reported Cobb had assaulted a black chambermaid named Ada Morris and thrown her down a flight of stairs. The article accused the Tigers of attempting to suppress the story, as it appeared in no other paper. Cobb's impressive athletic ability obscured a trail of belligerence and racism throughout his career. He was rarely popular with his teammates and was reviled by many fans.*

•

Instead of individual photos of players, the Liggett & Myers Tobacco Company issued this set of posed team photographs. Like the T222 set (page 132), these cards were printed on thin high-gloss photographic paper stock and were included inside tins of Fatima cigarettes. The set included all sixteen teams then in the major leagues. Each card provides the player's name; teams are identified by the city name and as either American or National League. As many cities had teams in both leagues, this can be a little confusing to viewers without detailed knowledge of who played for which specific teams. Photographs of more than three hundred players, managers, and mascots are included in this unique set, making it one of the more important documents of early-twentieth-century baseball.

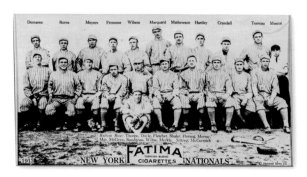

New York Giants

This team photograph of Gotham's best team includes their top pitcher and all-around favorite, Christy Mathewson, and one of the greatest multiple sport athletes ever, the incomparable outfielder Jim Thorpe.

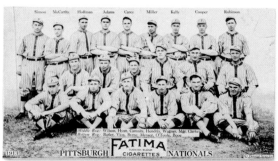

Pittsburgh Pirates

The early-twentieth-century Pirates were one of the National League's most consistent winners, appearing in the modern era's first World Series in 1903. Their success was due in no small part to one of baseball's greatest shortstops, Honus Wagner. Compared to other stars of the era, Wagner rarely appeared on cigarette cards. A popular rumor holds that he did not want his image used to promote tobacco. However, this has been called into question, as he was a known user of chewing tobacco. It's possible that he did not want his picture used on cards unless he received compensation.

130

Fatima Team Cards

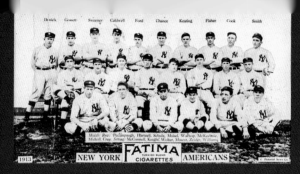

New York Yankees

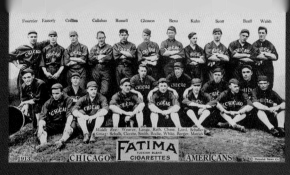

Chicago White Sox

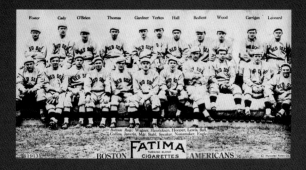

Boston Red Sox

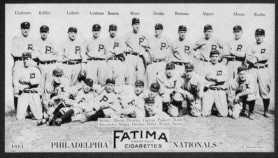

Philadelphia Phillies

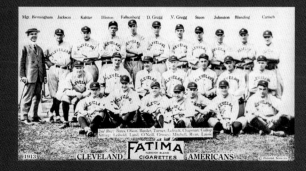

Cleveland Naps

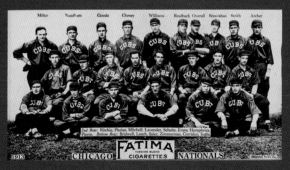

Chicago Cubs

Fatima

After the breakup of the American Tobacco Company, Liggett & Myers Tobacco Company, a former subsidiary, issued this set of glossy, sepia-colored photographic cards in packs of Fatima Turkish Blend Cigarettes. Nearly double the size of most other cigarette cards, the T222s are almost the size of the baseball cards issued later in the twentieth century, and they were printed on thin photographic paper stock. In addition to featuring athletes from other sports, the set includes portraits of actors and actresses. A small box on each card's lower right corner identifies the Pictorial News Co. as holding the images' copyright—freelance photographers often sold their photographs to companies such as Pictorial, which in turn sold them to newspapers and tobacco companies.

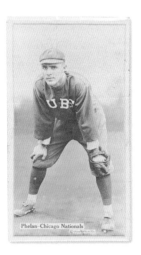
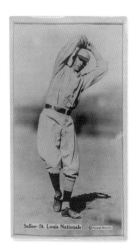
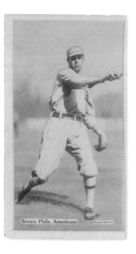
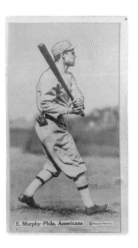

Above left: Art Phelan, infielder, Chicago Cubs
Above right: Harry Franklin "Slim" Sallee, pitcher, St. Louis Cardinals

———

Utilizing an unorthodox pitching delivery, Sallee confounded batters who faced him. Although he was one of the Dead Ball Era's greatest pitchers, he was stuck playing for one of the National League's worst teams. Later traded to the Cincinnati Reds, he pitched in the infamous 1919 World Series against the so-called Chicago Black Sox.

Above left: Carroll William "Boardwalk" Brown, pitcher, Philadelphia Athletics
Above right: Eddie Murphy, outfielder, Philadelphia Athletics

———

Murphy was a member of the scandalous 1919 Chicago White Sox. Because he was not among the eight players banned for life for their involvement in the fix, Murphy earned the nickname "Honest Eddie."

Similar to the Turkey Red Cabinets T3 (page 119) and the Old Judge Cabinets N173 (page 40), the cards in this set were offered as premiums in exchange for coupons distributed in cigarette packages. This set was issued in conjunction with the Obak T212 card set (page 82) and, like that set, featured minor-league players in the Pacific Coast and Northwestern Leagues.

The cards were printed on thick stock, and the photograph of each player—enclosed in a 3.5-by-5-inch oval frame—was often the same picture that was used to create the smaller T212 cards. No text identifies the team or player on the front of the card. On the back, scrawled in pencil, is a number that corresponds to a checklist of players included in the set.

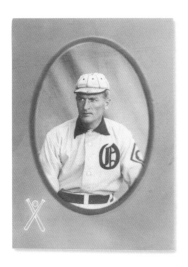

Harry Wolverton, manager, Oakland Oaks

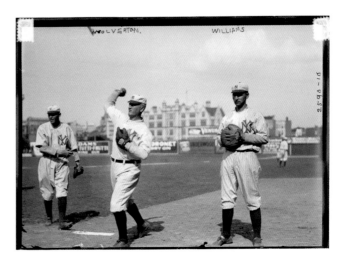

Harry Wolverton, manager, and Bob E. Williams, catcher, New York Highlanders, 1912. Photograph by Bain News Service

Wolverton had a successful career as a player for teams in both major leagues. In 1910, after a career as an outstanding infielder who rarely committed errors, he was hired to manage in the Pacific Coast League. He took over the struggling Oaks and turned the club around that season. Next he was offered the job of lifetime manager of the New York Highlanders, the team that was, in 1913, officially renamed the New York Yankees.

Wolverton's tenure as the Yankees' manager did not last long, despite the lifetime guarantee, although he occasionally inserted himself into games as a pinch-hitter. Fired after his first season, when the club finished dead last in the American League, Wolverton returned to the West Coast to manage minor-league clubs.

134

Old Mill Cigarettes

This expansive set includes eight distinct series, each representing a different minor league. With 640 cards, it is the largest twentieth-century tobacco set related to baseball ever issued. Its distinctive red borders, which stand out against the grainy, sepia-toned photographs, belie the obscurity of the subjects, many of whom were little-known minor-league players who never made the big time (thus their first names are often not present on these cards), although a handful were on their way up to the majors or on the long road back down. Represented leagues included the South Atlantic League, the Virginia League, the Texas League, the Virginia Valley League, the Carolina Association, the Blue Grass League, the Eastern Carolina League, and the Southern Association.

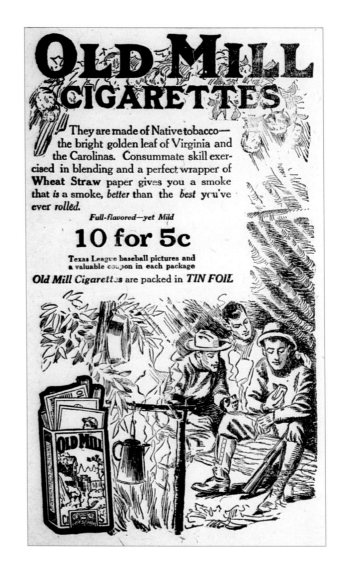

Advertisement for Old Mill cigarettes, *Palestine Daily Herald,* November 25, 1910

This ad, showing three young men sitting around a campfire looking at baseball cards, entices readers to buy Old Mill cigarettes with the promise that they'll find "Texas League baseball pictures" in each package.

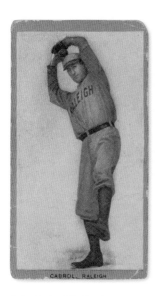

Cabrol, Raleigh Red Birds

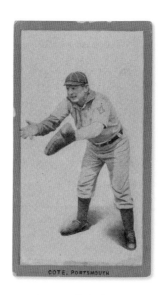

Cote, Portsmouth Truckers

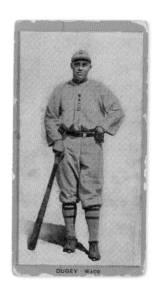

Oscar Dugey, second baseman,
Waco Navigators

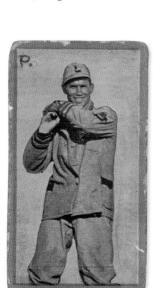

Harry Griffin, Lynchburg Shoemakers

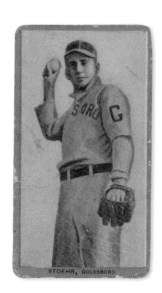

Stoehr, Goldsboro Giants

The Oklahoma City Daily Oklahoman *called Dugey "the best second baseman in the Texas League," but once he was called up to the big leagues, he was not a full-time second baseman. A utility infielder in baseball is a backup player who has the capability to play multiple positions in the infield. During the long season, when players get hurt or managers want to rest starters, the utility role is key, and Dugey filled that role for the Boston Braves and Philadelphia Phillies in the major leagues from 1914 to 1917, riding along on pennant runs with both teams.*

The Federal League (1913–15) is not well known to most baseball fans. However, Wrigley Field—one of the league's former ballparks—is one of the most famous, and oldest, parks in the majors. The Chicago Whales, not the Cubs, were the first team to call Wrigley their home. The stadium was then known as Weeghman Park, and it is the only Federal League ballpark still in use.

"Kansas City vs. Chicago, Opening Day, Chicago Federal League Baseball Park, Addison & Clark Sts., April 23, 1914. Attendance 28,496," 1914. Photograph by Kaufmann, Weimer & Fabry Co.

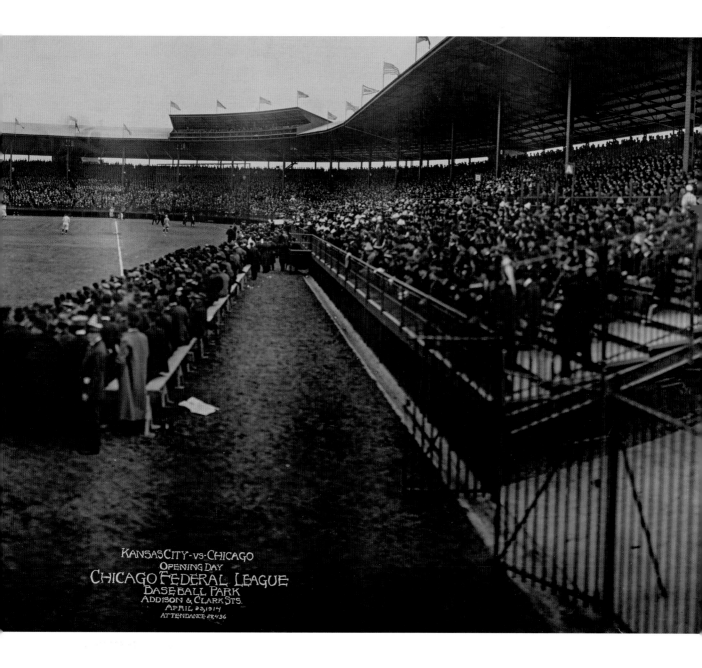

KANSAS CITY · VS · CHICAGO
OPENING DAY
CHICAGO FEDERAL LEAGUE
BASE BALL PARK
ADDISON & CLARK STS.
APRIL 23, 1914
ATTENDANCE 28,436

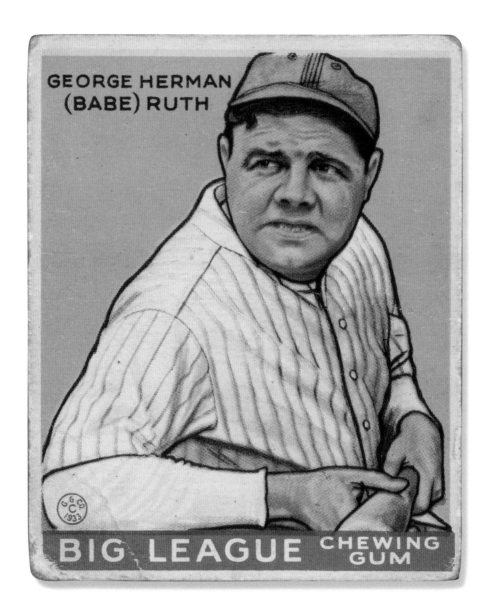

EPILOGUE

After April 1917, when the United States became an official combatant in World War I, the cigarette card slipped out of existence. The U.S. government asked industries that used products such as paper and ink to back the war effort by conserving these essential materials. Yet by 1918, as the previously small U.S. Army was numbering in the millions, the tobacco industry itself was booming. The War Department included cigarettes in soldiers' daily rations, making the U.S. government the world's largest tobacco buyer. By the end of the war, cigarette smoking had become more socially acceptable. Although U.S. states continued their prewar attempts to ban cigarette sales, the reinvigorated tobacco industry filed lawsuits and recruited lobbyists to fight the proposed restrictions.

By the 1920s, the tobacco industry was thriving as more than 70 billion cigarettes were sold each year in the United States. Brands such as Lucky Strike and Chesterfield were very popular, but the once ubiquitous cards had not reappeared in these peacetime packs. Tobacco marketing strategies had changed and now employed slogans and other forms of print advertisement. In *American Tobacco Cards* (1999), Robert Forbes and Terence Mitchell write that companies such as Reynolds introduced advertising campaigns that stated their "product was so good the company could not afford to distribute cards or premiums with it. This spelled the end of the second major tobacco card era," because other manufacturers soon followed suit.

As tobacco companies abandoned card production, chewing gum manufacturers, attuned to the popularity of cards among children, saw an opening. The American Caramel Company, Cracker Jack, and a handful of other candy companies had issued

George Herman "Babe" Ruth, outfielder, New York Yankees, 1933, Big League Chewing Gum, Goudey Gum Co.

The Fleer Corporation was soon joined in its production of baseball cards by the Goudey Gum Company of Boston. Goudey issued one of the most popular and dazzling card sets of the 1930s, the Goudey R319, and kicked off the bubble-gum card craze that would become a turning point in the history of baseball cards. Alongside the T206 (page 86), the Goudey set is considered among the most important sets of baseball cards ever produced.

Gum-packing department at the American Chicle Company plant, 1923. Photograph by Underwood & Underwood

Although chewing gum had been around since the mid-nineteenth century, it was not until the 1920s that its recipes improved and became wildly popular with children. Soon baseball cards were inserted into packs of various brands of gum and candy and kicked off another baseball card collecting frenzy.

card sets concurrently with tobacco companies in the early twentieth century. But it was not until 1928, when the Fleer Corporation of Philadelphia improved the recipe for bubble gum, that the chewy pink candy and blowing bubbles became sensations. Other candy manufacturers were soon competing with Fleer in the gum market, and the association between baseball cards and gum became an enduring part of childhood for generations of collectors.

The Black Sox scandal severely shook baseball, yet the sport previously had weathered other difficulties. From 1913 to 1915, the insurgent Federal League threatened the supremacy of the National and American Leagues and put the game's magnates on uneven ground as an antitrust suit was filed against the major leagues. Persistent rumors of owner corruption and tainted games led up to the fixed series of 1919. Maintaining the public

perception that baseball was an institution somehow above the greater faults of the country was made still more difficult as the United States coped with waves of post–Great War troubles. As Steven Riess notes in *Touching Base* (1980), "Many Americans were disillusioned with their country after World War I. The Black Sox scandal seemed to symbolize the rotting away of their way of life."

In 1920, as part of the fallout from the fixed World Series, league owners asked a tough U.S. District Court judge, Kenesaw Mountain Landis, to assume the newly created position of Commissioner of Baseball and clean up the game. That same year, the death of Cleveland Indians shortstop Ray Chapman, who was hit in the head with a darkish, stained ball that he probably never saw, led to changes in baseballs themselves. Umpires cracked down on the spitball, and scuffed, dirty balls were

replaced during games. The new, lively, so-called jackrabbit ball, which had a cork center, was rumored to increase home runs in the 1920s. Yet the rise in home runs may have had more to do with a free-swinging player named Babe Ruth, whose colossal blasts not only sent the ball flying but also seemed to ease fans' residual disillusionment from the previous decade.

As the Babe's reign over baseball began, cigarette cards, which had traced the growth of the game when it was still rough around the edges, faded into the background. The sepia-toned photographic cards that originally captured the gritty countenance of players, and the vibrant, artful renderings of the chromolithographic cards, with their vivid, embellished colors and ornate embossments, stand as striking examples of commercial printing. Fans loved the cards, which made no pretense to high culture or fine art. From a modern vantage point, as John Bloom writes in *House of Cards* (1997), "baseball cards have been, all at once, commercial artifacts, forms of visual media, advertising mechanisms, popular art, and objects of exchange."

Fans of the game today are awash in images of their favorite players. Television and computer screens now overshadow cards, which, in the late nineteenth century, provided many fans with the first images of their favorite players and teams. These cards were one of the first visual depictions of the game as it was being absorbed into the popular culture. By the turn of the twentieth century, baseball cards reflected the expansion and energy of America's great pastime during an era when the game's rawness and irreverence captivated a nation that was itself undergoing profound transformation.

Topps baseball card, 1965, showing Roberto Clemente, right fielder, Pittsburgh Pirates; Hank Aaron, right fielder, Atlanta Braves; and Willie Mays, center fielder, San Francisco Giants

The contours of race loom large in any survey of the baseball cards of the nineteenth and early twentieth centuries: for the most part, the cards do not include African American ballplayers. Once Jackie Robinson broke the color barrier in 1947 and the game became more integrated, black ballplayers started to receive the recognition and fame that had been denied to earlier generations of African American athletes. Topps® trading card used courtesy of The Topps Company, Inc.

FRANK C. IRONS

Other Cards in the Benjamin K. Edwards Collection at the Library of Congress

Phil Michel
Library of Congress Prints and Photographs Division

"Barbados" Joe Walcott, ca. 1888, Mayo's Cut Plug Prizefighters (N310)

Opposite: Frank C. Irons, track athlete, ca. 1910, Mecca & Hassan Champion Athletes & Prizefighters (T218)

Baseball card collecting is nearly as old as the game itself. Many of us picture it as a kids' hobby that reached its peak in the middle of the twentieth century, involving bubble-gum cards that were traded, flipped, or inserted into bike spokes. There are stories of found treasures in attics and basements, cards unseen for a hundred years that reap mortgage-sized windfalls at auction. Nostalgia and the thrill of the chase to find rare cards still drive thousands of card collectors today.

Benjamin K. Edwards (1880–1943), owner of a midwestern lumber company, loved that challenge, too. His pursuit, though, was not exclusively baseball cards. He collected a wide variety of late-nineteenth- and early-twentieth-century tobacco cards, appreciating, he said, "the luxury of tobacco enjoyment" and the ingenuity of these advertising gems. He amassed more than twelve thousand cards in total, which after his death were gifted to a family friend, the poet Carl Sandburg.

Edwards's love for the cards and the depth of his dedication to his hobby are evident in his collection. He carefully sealed his cards in

Lieutenant Ernest H. Shackleton, Antarctic explorer, 1910, Hassan World's Greatest Explorers (T118)

—

Hon. Phineas T. Barnum, showman and founder of Barnum & Bailey Circus, 1911, Miners Men of History (T68)

Matthew A. Henson, Arctic explorer, 1910, Hassan World's Greatest Explorers (T118)

—

Rose Pitonof, ca. 1911, American Tobacco Company, Champion Women Swimmers (T221)

cellophane packages and tucked them into collector's albums. Handwritten want lists and duplicates available for trading accompanied many of the sets. He corresponded and traded with other prominent card collectors, including Jefferson Burdick, author of the *American Card Catalog*, the first major collecting guide listing tobacco card sets.

Edwards noted in remarks about the tobacco card hobby that "the cards of greatest interest to collectors of today are the Military, Baseball and Thoroughbred Horses issues." Edwards was especially fond of the Kinney Military series cards, collecting a very extensive and challenging set of more than six hundred cards, contributing additions to the checklists, and even acquiring a printing proof sheet and an advertising display card.

Actresses and other female subjects also feature prominently in Edwards's collection, numbering nearly three thousand of his set. Early stage stars such as Lillian Russell appear on dozens of cards in a variety of costumes and poses such as those that prompted worries over the propriety of the pictures.

Willie Hoppe, billiards player, ca. 1910, Mecca & Hassan Champion Athletes & Prizefighters (T218)

When Edwards's collection was first transferred to Sandburg in November 1948, Oliver Barrett, the noted collector of Abraham Lincoln artifacts, fretted about the "moral aspects" of cigarette card collecting and feigned concern that his friend Sandburg would spend his days "looking at cigarette cards and not in the furtherance of American literature." Maybe the distraction indeed was too much for Sandburg. In 1954, Sandburg conveyed the collection to the Library of Congress so it could be preserved and shared with future generations, crediting Benjamin Edwards with gathering the collection but not acknowledging any concern over attendant moral questions himself.

The Benjamin K. Edwards Collection features stars in all the popular sports and pastimes of its day: baseball, prizefighting, horse racing, track and field, swimming, billiards, bowling, and chess. Beyond sports, hundreds of actors and actresses, inventors, explorers, world leaders and royalty, military heroes, flora, fauna, boats, trains, and numerous images of women in lurid poses appear in the cards. The collection encompasses these myriad subjects and offers a unique glimpse of turn-of-the-twentieth-century American interests and popular culture.

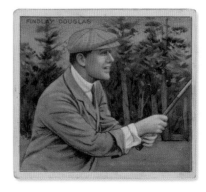

Findlay Douglas, golfer, ca. 1910, Mecca & Hassan Champion Athletes & Prizefighters (T218)

Clockwise from upper left:
Unnamed captain in U.S.
cavalry, 1886, Sweet Caporal
Cigarettes, Military (N224)

———

H. G. Crocker, cyclist, 1889,
Allen & Ginter World's Cham-
pions, 2nd series (N43)

———

Jockey Isaac Lewis aboard
Montrose, winner of the 1887
Kentucky Derby, 1890, Kinney
Brothers Famous Running
Horses (N229)

———

Northwestern University
basketball team, 1909, Murad
College Series (T51)

———

Sitting Bull, Hunkpapa Lakota
leader, ca. 1889, Kimball
Savage & Semi-Barbarous
Chiefs & Rulers (N189)

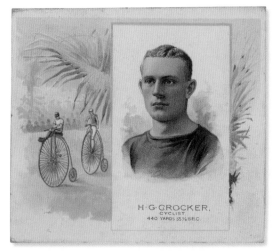

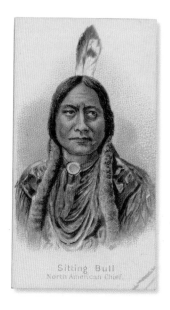

Clockwise from upper left:
William Beach, oarsman, 1888, Old Judge and Gypsy Queen Cigarettes, Goodwin Champions (N162)

———

Thomas Edison, inventor, 1888, W. Duke, Sons & Co. Great Americans (N76)

———

Benjamin Harrison, 1888, Honest Long Cut Presidential Possibilities (N124)

———

Paul Boynton, deep sea swimmer, 1888, Kimball Champions of Games and Sports (N184)

———

William Frederick "Buffalo Bill" Cody, showman and "Wild West Hunter," 1888, Goodwin Champions (N162)

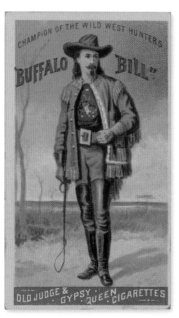

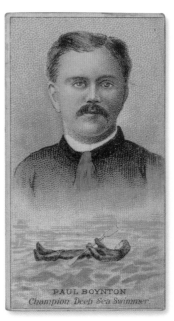

Bloom, John. *A House of Cards: Baseball Collecting and Popular Culture.* Minneapolis: University of Minnesota Press, 1997.

Brandt, Allen M. *The Cigarette Century: The Rise, Fall, and Deadly Persistence of the Product That Defined America.* New York: Basic Books, 2007.

Burdick, J. R. *American Card Catalog: A Gateway to the Enchantment of Days Gone By: The Standard Guide on All Collected Cards and Their Values.* New York: J. R. Burdick, 1953.

Carney, Gene. *Burying the Black Sox: How Baseball's Cover-Up of the 1919 World Series Fix Almost Succeeded.* Dulles, VA: Potomac Books, Inc., 2006.

Cruze, A. J. *Cigarette Card Cavalcade: Including a Short History of Tobacco.* London: Vawser & Wiles, 1955.

Forbes, Robert, and Terence Mitchell. *American Tobacco Cards: A Price Guide and Checklist.* Richmond, VA: Tuff Stuff Publications, 1999.

Gelzheiser, Robert P. *Labor and Capital in 19th-Century Baseball.* Jefferson, NC: McFarland & Company, 1997.

Goldstein, Warren. *Playing for Keeps: A History of Early Baseball,* 2nd ed. New York: Cornell University Press, 2009; 1st ed.: New York: Cornell University Press, 1989.

Goodrum, Charles, and Helen Dalrymple. *Advertising in America: The First Two Hundred Years.* New York: Harry N. Abrams Inc., 1990.

Hager, Alan. *Hager's Comprehensive Price Guide to Rare Baseball Cards*, vol. 1: *1886 to Present.* Lake Mary, FL: AHG, Inc., 1993.

Jamieson, Dave. *Mint Condition: How Baseball Cards Became an American Obsession.* New York: Atlantic Monthly Press, 2010.

Kirsch, George B. "Baseball Spectators, 1855–1870." *Baseball History* (Fall 1987).

Lipset, Lew. *The Encyclopedia of Baseball Cards: Volumes 1, 2, and 3 Combined.* Tacoma, WA: Pretty Panda Publishing, Inc., 1987. First published in 3 vols. in *Vintage & Classic Baseball Collector* magazine (1983, 1984, 1986).

Miller, Jay, Joe Gonsowski, and Richard Masson. *The Photographic Baseball Cards of Goodwin & Company (1886–1890).* By the authors, 2008.

Petrone, Gerard S. *The Great Seduction: Tobacco Advertising.* Atglen, PA: Schiffer Publishing Ltd., 1996.

Rader, Benjamin G. *Baseball: A History of America's Game*. Champaign: University of Illinois Press, 2008.

Riess, Steven A. *Sport in Industrial America, 1850–1920*. American History Series. Wheeling, IL: Harlan Davidson, Inc., 1995.

——. *Touching Base: Professional Baseball and American Culture in the Progressive Era*. Westport, CT: Greenwood Press, 1980.

Ritter, Lawrence S. *The Glory of Their Times: The Story of the Early Days of Baseball Told by the Men Who Played It*. New York: Macmillan, 1966.

Seymour, Harold. *Baseball: The Early Years*. New York: Oxford University Press, 1960.

Smith, Leverett T. Jr. *The American Dream and the National Game*. Bowling Green, OH: Bowling Green State University Popular Press, 1970.

Spalding, Albert G. *America's National Game*. New York: American Sports Publishing Company, 1911.

Sullivan, Dean A. *Early Innings: A Documentary History of Baseball, 1825–1908*. Lincoln: University of Nebraska Press, 1995.

Thorn, John. *Baseball in the Garden of Eden: The Secret History of the Early Game*. New York: Simon and Schuster, 2011.

United States Bureau of Corporations. *Report of the Commissioner of Corporations on the Tobacco Industry*. Washington, DC: Government Printing Office, 1909.

Voigt, David Quentin. *American Baseball*, vol. 1: *From the Gentlemen's Sport to the Commissioner System*. University Park: Pennsylvania State University Press, 1983; 1st ed.: Norman: University of Oklahoma Press, 1966.

——. *American Baseball*, vol. 2: *From the Commissioners to the Continental Expansion*. University Park: Pennsylvania State University Press, 1983; 1st ed.: Norman: University of Oklahoma Press, 1970.

Zappala, Tom, and Ellen Zappala, with Lou Blasi. *The T206 Collection: The Players and Their Stories*. Portsmouth, NH: Peter E. Randall Publisher, 2010.

Just as baseball is a team sport, creating a book is a team effort as well. I would like to acknowledge my own team, starting with the talented writers and editors in the Library of Congress Publishing Office, under the direction of Becky Clark. I owe an enormous debt of gratitude to editorial assistant Hannah Freece, who helped organize the art, conducted research, read the manuscript, and capably handled many other tasks. Peggy Wagner's thoughtful suggestions vastly improved the manuscript. I would also like to thank Susan Reyburn and Aimee Hess for their encouragement and help in shaping the proposal. Additional thanks to interns Caroline Bowman and Ellie Berger.

I had a lot of help in exploring the Benjamin K. Edwards Collection from the amazing staff of the Library's Prints and Photographs Division. First and foremost, I would like to thank Phil Michel, who was an early supporter of this project and helped select the cards featured in this book. Sara Duke also provided valuable information on the collection. Thanks to Ryan Brubacher and Eric Frazier for their assistance in tracking down illustrations used in the book. I also thank Cindy Moore for creating the Librarian's card on page vii.

It was my good fortune while writing this book to correspond with Major League Baseball's official historian, John Thorn. He graciously responded to every question I asked and shared his vast knowledge of our national pastime. His reassurance and advice helped get the manuscript over the finish line. I would also like to tip my hat to everyone with the Society for American Baseball Research, whose thorough excavation of baseball's history helped provide background for many of these players' bios.

A special thanks to our partners at Smithsonian Books: my editor, Laura Harger, for her acuity and guidance; Jody Billert, who helped with the sprawling array of images; and Christina Wiginton, whose insight helped organize the scope of the book. I am especially thankful to Josh Rosenberg for his diligent copyediting and to Antonio Alcalá and Studio A for the creative and sharp design that brings these cardboard relics to life.

Finally, I am grateful to my wife and children for their constant support during the writing of this book.

IMAGE CREDITS

Baseball cards in the Benjamin K. Edwards Collection can be located online by searching by player name and card set number at www.loc.gov/pictures/collection/bbc. Unless otherwise noted, all images in this book are from the Library of Congress Prints and Photographs Division and can be found by searching the ID numbers below at www.loc.gov/pictures. *b*: bottom; *t*: top; *l*: left; *r*: right; *c*: center; *a*: all.

ii: Tommy Leach, outfielder, Pittsburgh Pirates, 1911, Turkey Red Cabinets (T3). *iv*: LC-DIG-bellcm-06159. *vi*: LC-DIG-npcc-28195. *vii*: Artwork by Cindy Moore. *x*: LC-USZC2-326 (*t*); LC-DIG-ppmsca-17528 (*b*). *xii*: LC-DIG-pga-08978. *2*: LC-DIG-ppmsca-17526. *3*: LC-USZ62-89771 (*t*); LC-DIG-ppmsca-17527 (*b*). *8*: LC-DIG-pga-02608. *10*: LC-DIG-ppmsca-09310. *11*: LC-DIG-pga-00956. *15*: LC-DIG-ppmsca-55326. *19*: LC-DIG-pga-03935. *22* (*l*): LC-DIG-ds-09754. *23*: LC-USZ62-114266. *27* (*br*): LC-DIG-ds-03753. *29* (*r*): LC-DIG-ppmsca-09476. *30*: LC-DIG-ds-11798. *31*: LC-USZC4-1291. *32*: LC-DIG-ds-11799. *33*: LC-DIG-ppmsca-18403. *36*: LC-DIG-ppmsca-18773. *38*: LC-DIG-ppmsca-43952. *42*: LC-DIG-ppmsca-18406. *44* (*l, r*): General Collection. *45*: LC-DIG-pga-00601. *48*: LC-DIG-ppmsca-55329. *49*: LC-USZC4-6145. *50*: LC-DIG-ppmsca-18482. *51* (*a*): Music Division. *52*: General Collection. *54*: LC-DIG-ppmsca-09479. *55*: LC-DIG-ppmsca-28785. *56–57*: LC-USZ62-119636. *57* (*b*): Serial and Government Publications Division. *58*: LC-DIG-ggbain-03121. *61* (*l*): LC-DIG-ds-09755. *62–63*: LC-USZC4-6326. *64*: Rare Book and Special Collections Division. *66*: LC-DIG-ppmsca-18775. *67*: LC-DIG-ppmsca-26275 (*t*); Serial and Government Publications Division (*b*). *68–69*: LC-DIG-ggbain-14467. *70*: LC-DIG-ppmsca-51996. *72*: LC-DIG-ppmsca-18581. *73*: LC-DIG-hec-02444. *74–75*: LC-USZ62-97762. *76*: LC-DIG-ggbain-02266. *78*: LC-DIG-ppmsca-26379. *79*: LC-DIG-ggbain-14473. *80*: LC-DIG-npcc-03879. *90*: LC-DIG-nclc-01676. *92*: LC-DIG-nclc-04533. *93*: Serial and Government Publications Division (*t*); LC-DIG-ds-11800 (*b*). *98*: LC-DIG-ggbain-31278. *100*: LC-DIG-hec-01417 (*l*); LC-DIG-ggbain-13533 (*c*); LC-DIG-ds-11796 (*r*). *101*: LC-USZ62-134677 (*l*); LC-DIG-ggbain-09873 (*r*). *104*: LC-DIG-ppmsca-13545. *106*: LC-DIG-ppmsca-15832 (*bl*); LC-DIG-ppmsca-13542 (*br*). *107*: LC-DIG-ppmsca-13527 (*bl*); LC-DIG-ppmsca-15833 (*bc*); LC-DIG-ppmsca-13538 (*br*). *112*: LC-USZ62-64635. *114*: LC-DIG-ggbain-14494. *115*: Serial and Government Publications Division (*l*); LC-DIG-ggbain-25381 (*r*). *133* (*r*): LC-DIG-ggbain-12163. *134*: Serial and Government Publications Division. *136–37*: LC-DIG-ds-04552. *138*: LC-DIG-ppmsca-38379. *139*: LC-DIG-ppmsca-38380. *140*: LC-USZ62-102967. *141*: LC-DIG-ppmsca-19534. *142*: LC-DIG-ppmsca-55331. *143*: LC-DIG-ppmsca-55332. *144*: LC-DIG-ppmsca-55343 (*tl*); LC-DIG-ppmsca-55347 (*tr*); LC-DIG-ppmsca-55344 (*bl*); LC-DIG-ppmsca-55337 (*br*). *145*: LC-DIG-ppmsca-55333 (*t*); LC-DIG-ppmsca-55340 (*b*). *146*: LC-DIG-ppmsca-55726 (*tl*); LC-DIG-ppmsca-55335 (*tr*); LC-DIG-ppmsca-55334 (*cr*); LC-DIG-ppmsca-55330 (*bl*); LC-DIG-ppmsca-55339 (*br*). *147*: LC-DIG-ppmsca-55336 (*tl*); LC-DIG-ppmsca-55346 (*tr*); LC-DIG-ppmsca-55345 (*bl*); LC-DIG-ppmsca-55338 (*bc*); LC-DIG-ppmsca-55341 (*br*). *Endsheets*: All images from General Collection, Music Division, and Prints and Photographs Division

This book may be purchased for educational, business, or sales promotional use. For information, please write: Special Markets Department, Smithsonian Books, P.O. Box 37012, MRC 513, Washington, DC 20013

Published by Smithsonian Books in association with the Library of Congress
Director: Carolyn Gleason
Creative Director: Jody Billert
Managing Editor: Christina Wiginton
Editor: Laura Harger
Editorial Assistant: Jaime Schwender
Edited by Josh Rosenberg
Designed by Studio A

Library of Congress Cataloging-in-Publication Data
Names: Devereaux, Peter, author. | Library of Congress. Prints and Photographs Division. Benjamin K. Edwards Collection. | Library of Congress. Publishing Office
Title: Game faces : early baseball cards from the Library of Congress / Peter Devereaux and Library of Congress.
Description: Washington, DC : Smithsonian Books, 2018. | Includes index.
Identifiers: LCCN 2017060311 | ISBN 9781588346346 (hardcover)
Subjects: LCSH: Baseball cards—United States—History. | Baseball—United States—History.
Classification: LCC GV875.3 .D38 2018 | DDC 796.3570973/075—dc23

LC record available at https://lccn.loc.gov/2017060311

Manufactured in China, not at government expense
22 21 20 19 18 5 4 3 2 1